C000103822

Conten..

Introduction

A late eighteenth-century visitor to the area known as South Hawes on the south-west Lancashire coast would have been greeted by the sight of little more than a few humble fishermen's cottages and miles upon miles of golden sand dunes.

However, this stretch of the coast was already being feted as an ideal spot for sea bathing and in 1792 an enterprising pub landlord from nearby Churchtown decided to try and cash in on its growing popularity by erecting a bathing house there. Six years later this hopeful entrepreneur, William Sutton, built a small hotel on the same spot. He was widely mocked for his 'folly' at the time, but history shows that Sutton was, in fact, an astute businessman who realised the potential for a resort close to the newly constructed Leeds & Liverpool Canal.

Within thirty years this new resort, now called Southport, was becoming recognisable as the place we know today and already a thriving seaside town.

Edwardian era postcard of Lord Street.

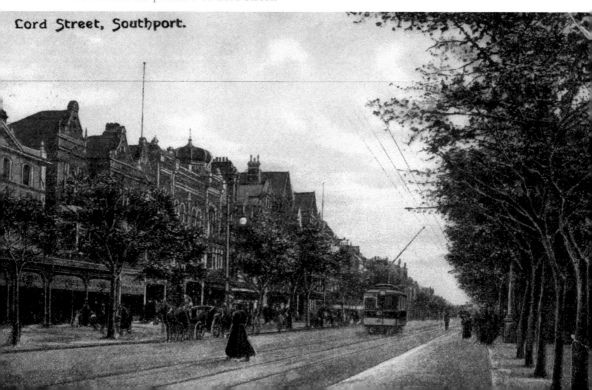

Lord Street, Southport.

Its progress continued at pace throughout the nineteenth century with the transformation of Lord Street into a tree-lined boulevard, the construction of the Promenade and the erection of Southport's much-envied iron pier, still the second longest in the country. By now William Sutton was celebrated as being Southport's founder, although, as we shall see later, this version of events has subsequently been questioned by some local historians.

Unsurprisingly, such a thriving resort attracted some high-profile visitors. The future French Emperor Napoleon III is reputed to have stayed for a time in the town, as did two of the great nineteenth-century American novelists, Nathaniel Hawthorne and Herman Melville. Another frequent nineteenth-century visitor was the real-life 'Greatest Showman', P. T. Barnum.

By the time that near neighbours Birkdale and Ainsdale amalgamated with Southport, the sea was without question retreating from the shoreline, not an easy prospect for a resort that had created its reputation on sea bathing. The then highly proactive Town Council confronted this issue head-on by creating the Marine Lake in front of the Promenade. This proved immediately popular and remains one of Southport's most recognised attractions today.

I probably should nail my colours to the mast at this juncture by declaring my lifelong affection for Southport, ever since I was fortunate enough to spend several happy years as a child living in Ainsdale during the early 1970s. One of the qualities I love most about Southport has been its ability to meet challenges and adapt in the face of changing circumstances. As far back as the 1920s, Southport's

Marine Lake.

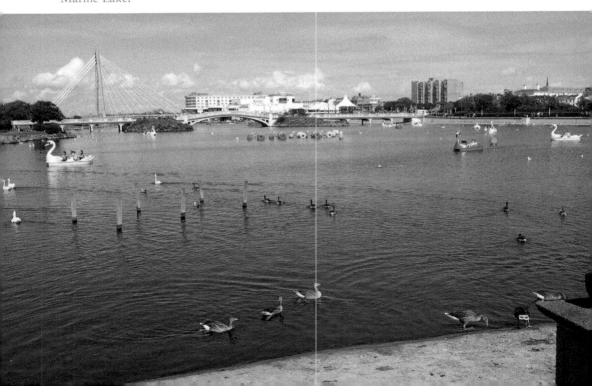

leaders realised the necessity of finding new ways to promote the resort as a tourist destination. The annual Flower Show was launched in 1924 and Southport was marketed as the perfect location for top golf tournaments. Both schemes have continued to bear fruit right up to the present day.

As the twentieth century progressed, Southport, along with other UK seaside destinations, became increasingly badly hit by the arrival of cheap air travel, making it more affordable to holiday abroad. This presented the town with huge challenges. Even the iconic Victorian pier was threatened with demolition at one point. Happily, this was preserved for posterity following a restoration project in the early 2000s, along with other major redevelopment work near the seafront. The town's leaders also revisited the idea of providing landmark events that would increase footfall to the town such as the annual Southport Air Show, which was held for the first time in 1991.

Southport continues to face challenges, in common with so many other seaside resorts. I have no doubt, however, that it will remain a place that residents are proud to call home and to which visitors will wish to return. In writing this book I am glad of having this opportunity to celebrate what the town, which I am proud to have once called home, has achieved in the past and what it continues to offer in the present. It will be fascinating to see how it progresses in the future.

Scarisbrick Hotel, Lord Street.

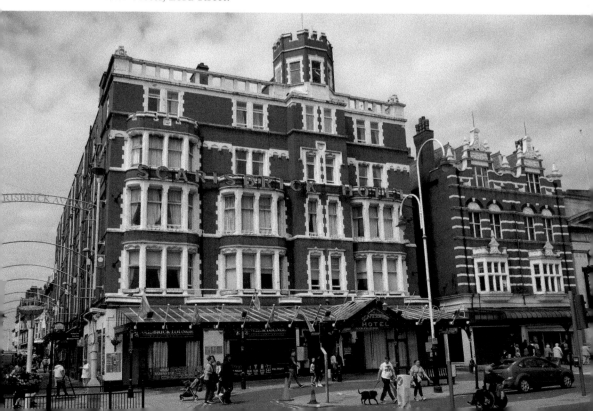

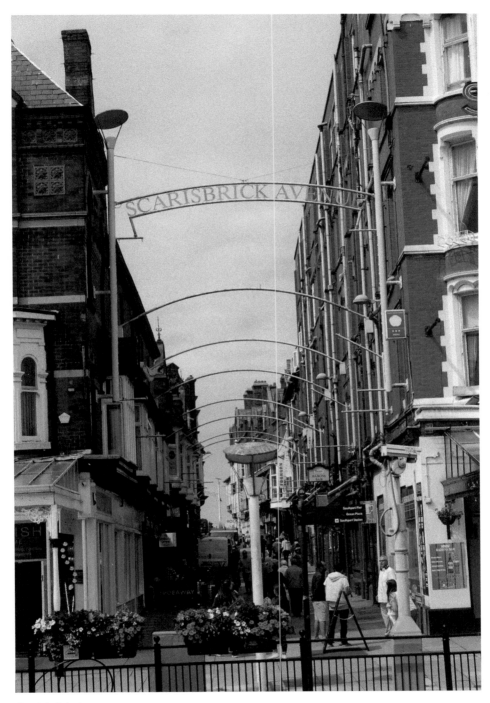

Scarisbrick Avenue.

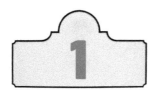

How It All Started

Two stone tablets to be found on a wall at the southern end of Lord Street give a clue as to how it all began in Southport. They commemorate a man called William 'Duke' Sutton, who is widely recognised as being the town's founder.

Sutton was born, in 1752, in nearby Churchtown, then part of the historic parish of North Meols. Following his marriage, in 1776, to a local girl named Jane Gregson, he became landlord of the Black Bull Inn (now called the Hesketh Arms) in Churchtown. At some point he acquired the nickname 'Duke', reputedly because of his tendency to boast about the occasion on which he met a relative of King George III.

An annual August fair had long been celebrated in Churchtown in honour of St Cuthbert, the patron saint of the parish of North Meols, and over time this

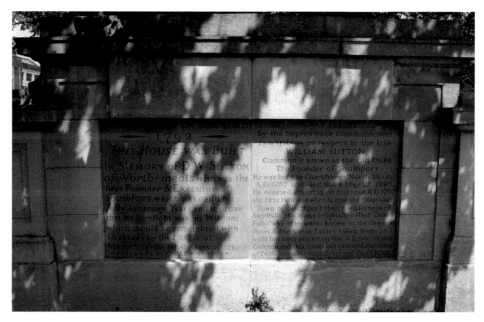

Stone tablets commemorating William Sutton.

gradually developed into a sea bathing festival. 'Great Bathing Sunday', as it came to be known, was held each year on a Sunday near the end of August. Visitors would descend on Churchtown to enjoy the festival and the prospect of some sea bathing. Many would return a fortnight or so later for 'Little Bathing Sunday' down the coast in Birkdale, then little more than a small fishing settlement.

In due course both festivals were scrapped as a result of pressure from the religious authorities, who expressed outrage that the events had become little more than an excuse for heavy drinking and riotous behaviour. By this time, however, the reputation for fine sea bathing at North Meols was becoming well established.

During the latter part of the eighteenth century, sea bathing also became a highly fashionable pursuit among the upper classes of society. The health-giving properties of sea water were widely publicised and a dip in the sea was believed to cure all manner of ailments. Even the then monarch, King George III, was known to be a fan. A different class of visitor with more money to spend soon became interested in coming to North Meols.

Access to the North Meols coast was much improved by the opening of the Leeds & Liverpool Canal in 1774. Churchtown's innkeepers would arrange for visitors to be picked up from the Red Lion Bridge near Scarisbrick and transported to their establishments at Churchtown less than 5 miles away. William Sutton was one such innkeeper. The nearest beach to Churchtown was at neighbouring Marshside, but it soon became apparent that visitors preferred the golden sands of South Hawes, about 2 miles further down the coast. William Sutton would arrange for his guests to be taken in donkey carts to what was then only a sparsely populated area that offered little in the way of facilities.

In 1792, the enterprising Sutton decided to build a shelter close to the beach at South Hawes for the use of his guests, giving them not only a place to change in and out of their bathing gear, but also to have a drink and relax. This shelter was a simple affair and inexpensive to build, being made from driftwood and the remains of wrecked ships found on the beach.

Six years later Sutton undertook a more ambitious scheme when he decided to build a more permanent building near to his original bathing shelter, at the southern end of what is now Lord Street. At the time this area appeared on maps as 'the new Marish', or 'new Marsh', and, as the name suggests, was no more than a marshy valley positioned between two ridges of sand dunes. Sutton was widely mocked for undertaking this scheme in such an unpromising location and the hotel was unkindly called the 'Duke's Folly' by his critics.

The hotel underwent a series of name changes over the years, becoming the Royal Hotel and later the Original Hotel, although the 'Duke's Folly' nickname appears to have remained in usage as well. However, it is the name by which the hotel became known early on in its life that bears the most significance. It was called the South Port Hotel and South Port soon seems to have been applied generally to the settlement that began to develop around it, replacing the area's original name of South Hawes.

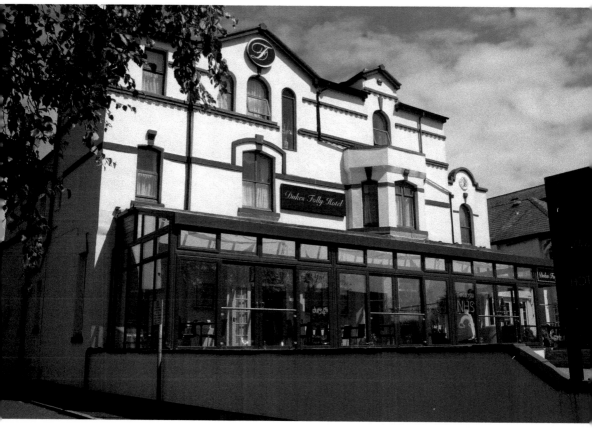

Modern Duke's Folly Hotel, named in honour of William Sutton's Original Hotel.

A visitor to the area in the early 1800s called Thomas Glazebrook, who, in 1809, wrote *A Guide to Southport,* was probably the first to offer an explanation in print as to how Sutton's hotel acquired its name. He suggested that the area around South Hawes had formerly possessed 'a fine bay of eleven fathom water, within half a mile from shore, where vessels occasionally lay securely at anchor, consequently it was a *Port* to them in every sense of the word'. He goes on to say that was why Sutton called his hotel 'South Port'.

Unlikely as it may sound today, the area where the Marine Lake is now situated used to be a sandy beach and at high tide the sea used to come in all the way up to the Promenade. It was not until the latter part of the nineteenth century that the sea started to beat a hasty retreat as a result of changes to tidal currents. Even allowing for this, though, it still seems unlikely that there ever existed an area within half a mile of shore suitable for cargo-carrying vessels of any significant size to drop anchor and unload goods.

Significantly, by the time the second edition of Glazebrook's book was published in 1826, the writer had amended his story, now claiming that,

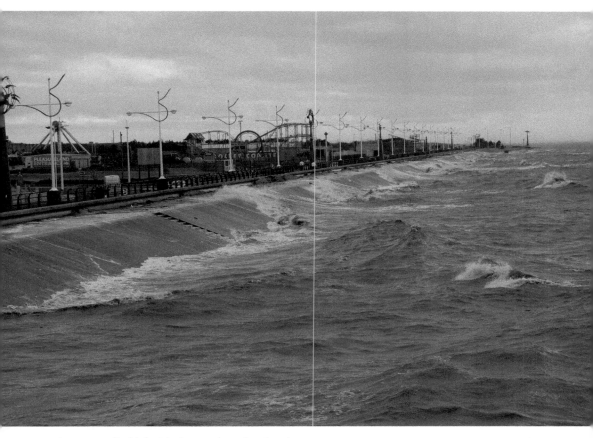

An unusually high tide for modern-day Southport.

> The village received its present appellation from the late Mr Barton, at an entertainment given by Mr Sutton, on the opening of his new inn. The Doctor, during the evening, took a bottle of wine, and dashing its contents about him, emphatically said, 'This place shall be called South Port'.

This account led some wits to suggest that the establishment was to be named the 'South Hawes Hotel'. However, when the toast was about to be made, Mr Barton forgot the name and so turned to the port wine in his glass for inspiration. Sadly, we shall probably never know for certain, but the hotel's name became synonymous with that of the emerging resort and by the mid-1820s the two words had been merged into one, giving the modern name of 'Southport'.

As for Sutton's hotel, the original building was significantly extended in 1845 and this is thought to be the point at which a stone tablet proclaiming William Sutton as Southport's founder was placed over the door. Sutton himself had died in 1840 and the tablet is believed to have been made by his son, John, who was a stonecutter by profession, in tribute to his late father. The inscription on the tablet reads:

IN THE YEAR OF OUR LORD 1792 THIS HOUSE WAS BUILT. IN MEMORY of D.W. SUTTON of North Meols, who was the first Founder and Executor of SouthPort, which was called his Folly for many years, and it proves that his foresight was his Wisdom which should be remembered with Gratitude by the LORDS of this Manor and the inhabitants of this PLACE ALSO.

By the early 1850s, the Original Hotel was increasingly viewed as obstructing further development, blocking, as it did, the southern end of Lord Street. When plans were drawn up in 1854 to build a new road (now Lord Street West) that would link the town centre with new building developments taking place in Birkdale, the hotel was demolished.

Six years later a monument was erected on the site of the former hotel by the town's Improvement Commissioners, incorporating the stone tablet that had previously been mounted above its door and a new, second tablet which read,

THIS COLUMN WAS ERECTED AD1860 by the Improvement Commissioners as a tribute of respect to the late WILLIAM SUTTON, commonly known as the Old Duke. The Founder of Southport … He erected almost upon this spot AD1792 the First House in what is now the flourishing town of Southport, then a wilderness of Sandhills, the house originally called 'Duke's Folly' was afterwards known as the Original Hotel...

Vintage lighting near William Sutton's stone tablets.

Thus, the tradition of William Sutton as the founder of Southport was quite literally 'set in stone'. Yet, only forty years later, local historian Edward Bland set out to disprove the notion of Sutton as the town's founder. An outspoken critic of this view, Bland asserted in *Annals of Southport and District* that,

> Old traditions die hard, and it will be difficult for many people to believe that the Old Duke was not the founder of Southport or the builder of the first house in it. As a matter of fact his share in the earlier affairs of the town was accidental, late in the day, and very subordinate in value.

Bland appears to have been correct on one point. Almost certainly, Sutton was not the first to offer accommodation to tourists visiting the beach at South Hawes. Their visitors may not have been wealthy or fashionable, but it seems likely that the fishermen who already lived on this part of the coast may have taken in paying guests long before Sutton's enterprise in 1792. Moreover, a year before Sutton erected the Original Hotel, Sarah Walmsley, a widow from Wigan, leased a plot of land near to the spot where Sutton's bathing shelter was situated and built a large cottage there called 'Belle Vue'. She started taking in paying guests and this could well be what motivated Sutton to build his own hotel the following year. This may also explain why history was apparently rewritten in the stone tablets commemorating his contribution to the town in their description of Sutton building his 'first house' there in 1792, when it now appears certain that this was little more than a bathing shelter and the hotel did not follow until 1798.

More recent historians such as F. A. Bailey have been a little kinder to William Sutton. The 'Old Duke' may not have been solely responsible for Southport's foundation, but, as Bailey asserts in his *A History of Southport*, Sutton's enterprises in 1792 and 1798 'did materially contribute to the development of what was in effect a new town'.

The stone tablets were removed from the monument in 1899 and the monument itself was later demolished in 1912. The tablets were, however, subsequently mounted on the wall at the southern end of Lord Street, close to where the monument once stood, and this is where they remain today.

Along the Promenade

By the early 1830s, Southport was already developing into a popular seaside holiday resort, whose streets now boasted several hotels. The town's population had also increased dramatically during the previous decade. The resort's rapid expansion did, however, cause some previously unforeseen difficulties.

Southport was built on sand and, as time progressed, the problems caused by sand drifts became ever more apparent. In 1831, a local author named Peter Whittle commented that at Lytham, another fashionable resort up the coast, 'your walks are not impeded by the depth of the sands, in order to approach the sea, as they are at Southport'.

The issue clearly had to be addressed and in 1835 a company was formed to undertake the project of building a sea wall and promenade. It is a sign of the town's developing status that investors were prepared to commit funds to such a costly venture. The Promenade initially stretched from what is now Coronation Walk to Nevill Street. A second company, the Southport New Baths Company, was formed soon afterwards with the intention of extending the Promenade further northwards. Once the sea wall was in place, the Promenade quickly became a popular location for private residences, as well as hotels.

The Royal Victoria Baths were also constructed at around this time and were officially opened with great ceremony in May 1839. The original structure was replaced in 1871 by the Grade II listed building that still stands on the corner of Nevill Street and the Promenade today. Once one of the grandest public baths in the country, the building is sadly now no longer in use. However, in view of its prominent position on the Promenade, one can only hope that an investor will be found who has the vision to restore this once fine building to something approaching its former glory.

In August 1859, work began on an exciting new project. Southport's famous iron pleasure pier opened the following year and proved to be an immediate success. It was extended eight years later to reach a deeper channel further from the shore. This allowed steam ship companies to run services from the pier head, linking Southport with other Lancashire resorts like Blackpool and Lytham, but also further afield to places such as the Isle of Man and North Wales.

Royal Victoria Baths.

With a new length of 1,460 yards, Southport's pier became the longest in the country. The engineer responsible for its design, James Brunlees, was later involved in the construction of an even longer iron pier at Southend, but to this day Southport Pier remains the second longest in Britain.

Today the pleasure steamers have long gone. Towards the end of the nineteenth century, it became increasingly apparent that the shoreline was rapidly receding,

Southport Pier and modern Marine Way Bridge.

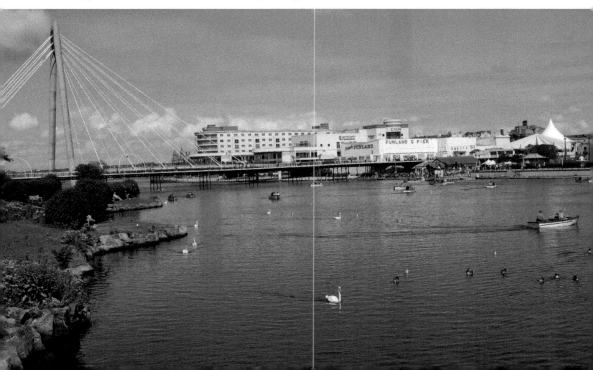

largely as a result of the dredging of the River Ribble up the coast to allow the development of Preston Docks.

By this stage the town had been incorporated as a municipal borough and so the onus to act fell firmly on the shoulders of Southport Corporation. The first step was to acquire ownership of the foreshore from the lords of the manor. Once it was in municipal hands, the Corporation began to formulate a plan that would effectively extend Southport's foreshore outwards towards the sea.

Work on the foreshore to the south-west of the pier began and the first section of the Marine Lake was opened in 1887. The area to the north-east of the pier was similarly developed five years later and in 1895 the two sections were combined to create one of the largest man-made leisure lakes in the country. At the same time the Marine Drive was constructed.

Initially, the South Marine Lake was surrounded by sand, but gradually the beach was replaced by gardens. During the Edwardian era the gardens were developed on a more formal basis and were named 'King's Gardens' in honour of George V, who, accompanied by Queen Mary, performed the official opening ceremony in July 1913. This was a particularly auspicious occasion, as it represented the first ever visit to Southport by a reigning monarch. In 2014, the King's Gardens were officially reopened by the royal couple's granddaughter, Princess Alexandra, following extensive restoration work.

Marine Lake to south-west of the pier.

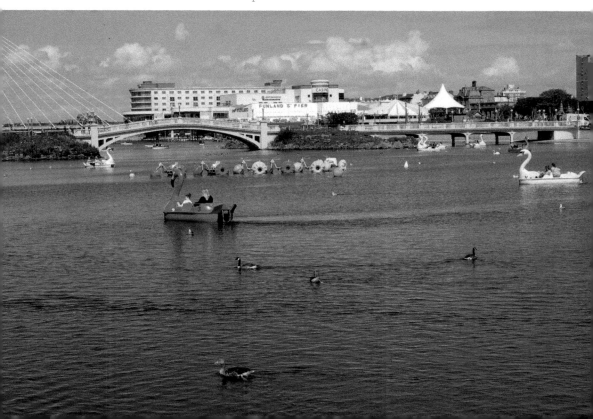

Above: Marine Lake to north-east of the pier.

Below: Marine Drive at high tide.

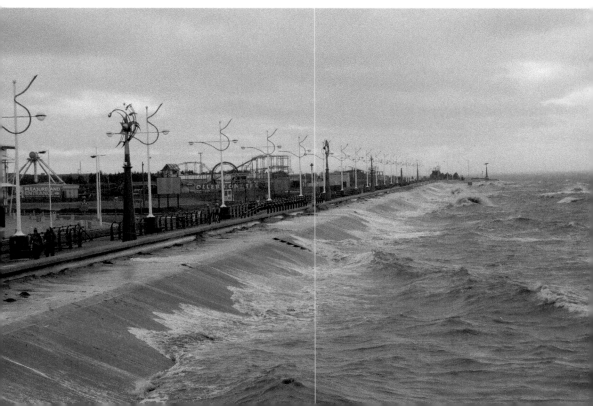

Following the end of the First World War, the then Borough Engineer A. E. Jackson came up with an innovative idea to solve the problem of how best to develop the area of unsightly waterlogged wasteland, known as 'The Lagoon', between the South Marine Lake and the Marine Drive. Using the town's rubbish as landfill to raise the level of the site, the land was transformed into Princes Park.

The development of Princes Park led, in 1931, to the construction of the Venetian Bridge, which was designed to enable easier access to the new attractions in Princes Park across the Marine Lake. In recent years, this ornamental bridge has been painstakingly restored and remains one of the resort's most notable landmarks.

An ambitious new open-air swimming pool became one of Princes Park's most popular attractions. Opened in May 1928, it was constructed to replace the resort's earlier outdoor baths, which had been in use since 1914. The new open-air pool's design resembled a Roman amphitheatre, with a circular swimming pool surrounded by tiered seating and a café that featured an impressive domed roof. A covered arcade ran round the sea-facing side of the pool, which, as well as being aesthetically pleasing, provided the intrepid open-air bathers with some protection from the elements.

Venetian Bridge.

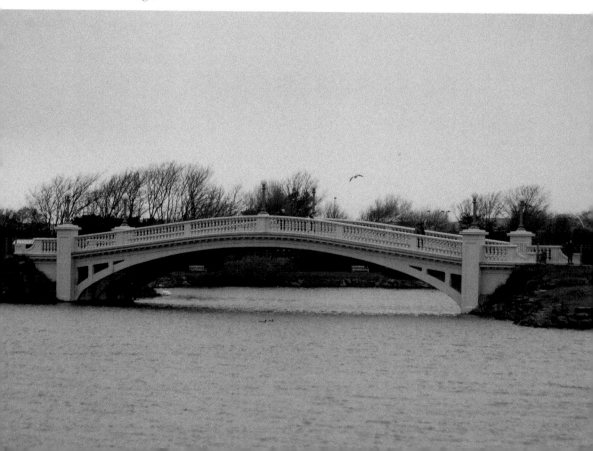

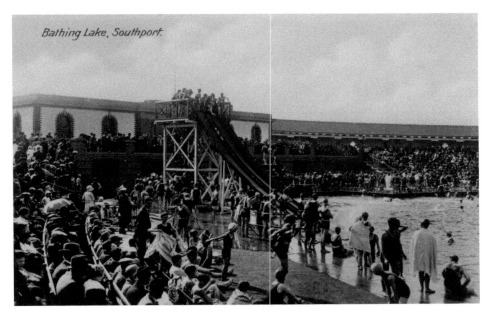

Former open-air swimming pool.

The pool became a popular venue for beauty pageants, but hosted other events too. In September 1969, Black Sabbath, headed by the inimitable Ozzy Osbourne, performed to a huge crowd from a platform in the middle of the pool.

However, the giant open-air structure became ever more costly to maintain in a good state of repair and, with visitor numbers rapidly declining during the 1970s and 1980s, it became unprofitable to run. The open-air pool eventually was closed in 1989 and was demolished in 1993.

As the new millennium approached, the now derelict sites on Princes Park were in constant danger of flooding. After an agonising delay because of funding issues, work finally began on a new sea wall in 1997.

However, there were still other problems to overcome. The Victorian cast-iron bridge on Marine Way, which for nearly a century had connected the seafront with the town centre, was declared unsafe and was eventually demolished.

Even Southport's iconic pier was at one point threatened with demolition, when, faced with repair costs of around £1 million, a council resolution to demolish the structure was defeated by just one vote. Eventually, in 1997, the pier had to be closed for safety reasons and it was only possible to start restoration work after sizeable funding was obtained from the Heritage Lottery Fund.

Happily, the pier finally reopened in 2002, complete with a new modern pavilion at the pier head. As well as housing a café, this building is also home to a collection of vintage amusement arcade slot machines, which may still be played using old pre-decimal pennies.

Left: View looking down the pier.

Below: Modern pavilion at the pier head.

Once improved sea defences along Marine Drive were in place, plans for a new seafront development also began to emerge. The appearance of Southport's seafront changed forever with the Ocean Plaza development, which was opened in 2002. This modern complex may not have the aesthetic appeal of the former open-air swimming pool. Nevertheless, with its selection of restaurants, leisure facilities and retail outlets, the Ocean Plaza has successfully attracted visitors back to a part of the town that had previously suffered from years of neglect.

The crucial road connection between Marine Drive and the town centre was restored when a new bridge, to replace its Victorian predecessor, was constructed across the Marine Lake. The Marine Way Bridge was officially opened by Prince Edward and Sophie, Countess of Wessex, in July 2004. Designed by engineering consultants, Jacobs Babtie, with award-winning architects Nicoll Russell Studios, this magnificent suspension bridge has now become a landmark in its own right.

No chapter regarding Southport's seafront attractions would be complete without referring to Pleasureland.

Enterprising entrepreneurs had long sought to profit from the vast number of holidaymakers arriving in the town during the summer. In the resort's early days, they tended to congregate on the beach, close to the Promenade, much to the displeasure of some such as the writer who, in 1877, complained that 'the exhibition of buffoonery and fair ground in the sands near the pier' detracted from 'the respectability of the place'. In the late 1890s, the fairground stalls were moved to the

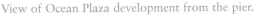
View of Ocean Plaza development from the pier.

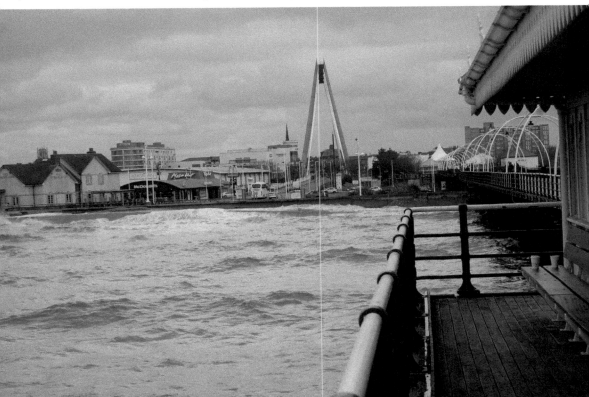

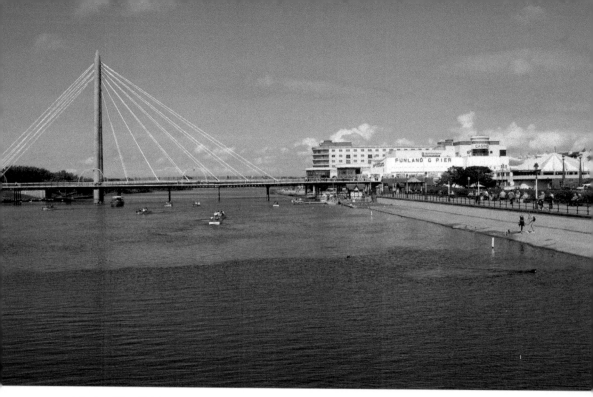

Marine Way Bridge.

south end of the Marine Lake. As well as appeasing those who had called for greater respectability in the vicinity of the Promenade, practicality also dictated this move, as the amusement rides were becoming larger and required more space.

In 1895, a brand-new attraction reached Southport in the form of the Switchback Railway, which is now regarded as the precursor of the modern rollercoaster. It was soon followed by the Water Chute, on which passengers were propelled down a steep chute in a boat-shaped carriage to the Marine Lake below. Sir Hiram Maxim's Captive Flying Machine, which was unveiled in 1904, was another early favourite. Sadly, this was demolished at the end of the 1933 summer season in the name of 'progress', but a similar ride remains in operation at Blackpool Pleasure Beach to this day.

Soon after the end of the First World War, the number of amusement rides had increased to such an extent that it was decided to create a new enclosed site and, in 1922, Pleasureland was opened.

One of Pleasureland's most popular landmarks, the Noah's Ark, was constructed in 1930. This walk-through attraction was similar in style to a fun house with various amusing surprises to be encountered along the way including moving stairs and unexpected jets of air. The Noah's Ark took the form of a large rocking boat on the top of a 'mountain' (presumably meant to be Mount Ararat) with a house on top, which featured various sculptures of Noah and the animals. Sadly, the Noah's Ark was destroyed by fire, in 1977, and although a similar attraction

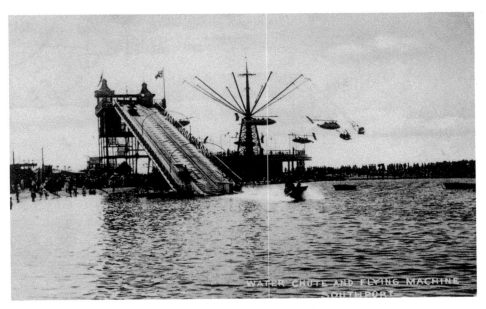

Water Chute and Sir Hiram Maxim's Captive Flying Machine.

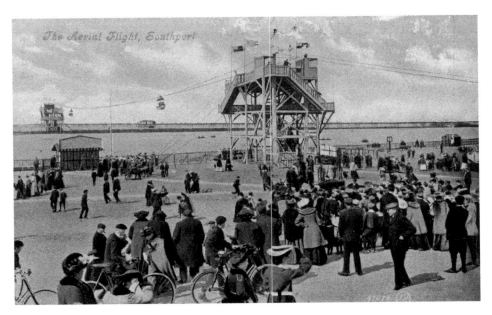

Aerial Flight ride.

survived at Blackpool Pleasure Beach until well into the new millennium, it too is now no longer in operation.

In the autumn of 2006, the amusement park was suddenly closed without warning by its then owners, Blackpool Pleasure Beach, following a dramatic

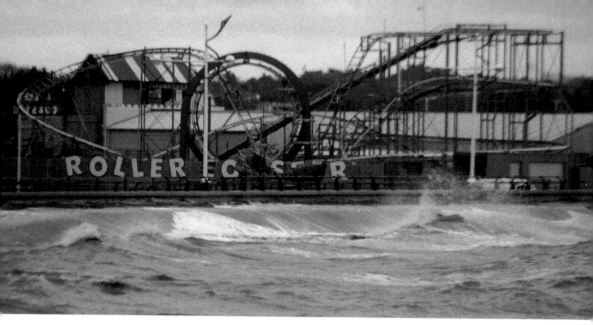

Above: Pleasureland Rollercoaster.

Below: Pleasureland.

decline in visitor numbers. Almost immediately, work began on the demolition of the site including some of Pleasureland's most historic rides such as its iconic wooden rollercoaster, The Cyclone. Southport may well have lost one of its most treasured visitor attractions forever if businessman Norman Wallis had not stepped in to purchase the site and in recent years he has done much to rejuvenate Southport's famous amusement park.

3

Away from the Seafront

The resort of Southport may well have owed its initial success to the suitability of its coastline for sea bathing and its miles of golden sands, but it is fair to say that it would not have achieved the reputation it still enjoys today without the development of Lord Street into the spacious tree-lined boulevard so loved by visitors past and present.

Southport's early development away from the seafront gave little hint of the success that was to come. Buildings were erected in a haphazard fashion with little or no regard for future planning, added to which the marshy and waterlogged ground on which they were constructed caused a variety of issues.

Lord Street Bandstand.

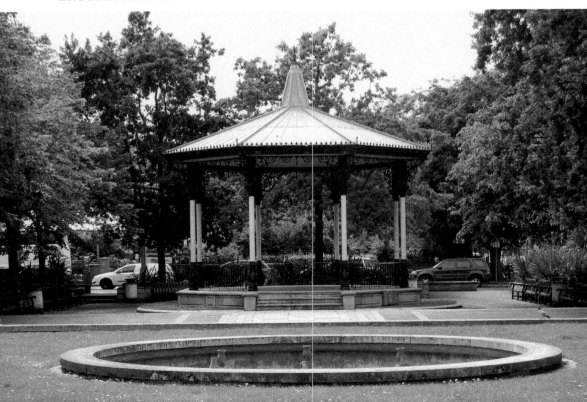

In 1805, a second hotel, the Union, opened on a plot adjacent to William Sutton's original hotel to accommodate the increasing number of visitors attracted to the area by its growing reputation for excellent sea bathing. In 1876/77, the Union was replaced by the Prince of Wales Hotel, named after the future King Edward VII who had recently visited the town.

However, Southport's famous thoroughfare only began to develop into a form recognisable today from around 1820 onwards. 'Lords Street', as it was originally known, is assumed to have been named in honour of Southport's two lords of the manor. The land on which the resort took shape initially formed part of an estate owned jointly by two of the area's most important landowning families, the Fleetwood-Heskeths and the Bold-Hoghtons. At first, they took only limited interest in the new resort, probably envisaging that it would amount to little more than a few properties. However, as Southport increased in importance, its landlords started to exert more control. They began granting leases for building on Lord Street, with the stipulation that the development could not be of an industrial nature.

In early 1821, a new boat service was introduced on the canal which for the first time brought passengers from Manchester to Scarisbrick. Later the same year, the *Liverpool Mercury* reported that 'We understand that the resort of company to Southport this summer has been great beyond all former example. Lodgings, in the month of August, were not to be procured on any terms.' Plans were already

Christ Church, Lord Street.

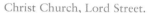

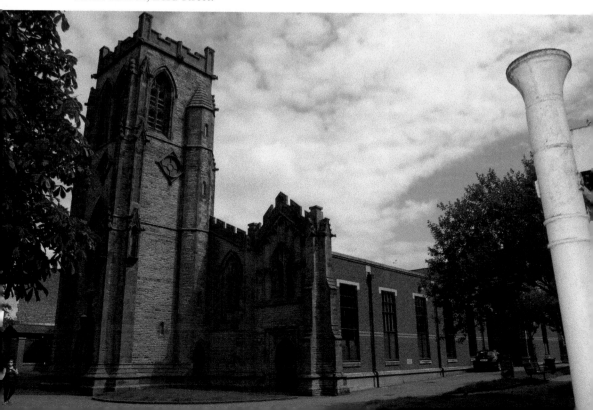

being made to remedy the situation. The paper reported that many new houses were to be built 'in the line from the Union Hotel towards the new Church' (i.e. Christ Church on Lord Street, which the previous year had become the first place of worship to be constructed in Southport).

Within a decade or so, Lord Street extended as far as The Bold hotel, which now has the distinction of being Southport's earliest surviving hotel. Some other roads, instantly familiar today, such as Nevill Street and London Street, were also beginning to appear for the first time on plans of the town.

As tempting as it is to attribute the impressive width of Southport's grand boulevard to careful town planning, the way in which it evolved owes much to the marshland on which the properties were originally developed. Because of lingering concerns regarding the muddy conditions that persisted at time of heavy rain, the homes on the landward side were built well back from the road with long front gardens. As the properties on the seaward side were originally constructed closer to the road, these lent themselves more naturally for conversion into retail units, meaning that, over time, the houses on the side of the street nearer to the promenade were gradually converted into shops, whilst the properties on the other side remained as domestic dwellings.

A later marketing campaign would brand Southport as the 'seaside garden city', but, from early in the resort's development, Lord Street's domestic properties were well known for their gardens. An 1842 visitor, Thomas Tidmarsh, praised Lord

The Bold.

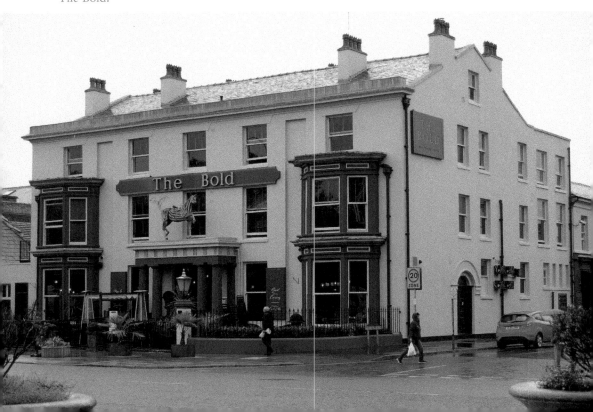

Street's 'graceful' homes, 'some with grass plots before them, bloomingly gemmed with buttercups and daisies; others with gardens luxuriating in flowers, and rich in loveliness and perfume'.

Lord Street has also been long renowned for the decorative iron and glass canopies, which run nearly the entire length of its seaward side. A young trader called Charles Barrow is thought to have been the first to erect an ornamental iron canopy in front of his Lord Street premises in the early 1860s and other shop owners soon followed suit. The ambitious young Barrow has also been credited with suggesting that a public garden be created on its inland side, but it was Southport's Improvement Commissioners (the forerunners of the later Southport Corporation) who took on the responsibility of creating the fine Municipal Gardens, which are still enjoyed by visitors today.

In 1871, an Irish visitor named Catherine Winter remarked, 'The beauty of Lord Street is that it looks like a long avenue of trees, as you look up and down, with spires of churches and tops of chimneys peeping over the lovely foliage, of all dimensions and of every variety and description ... Champs Elysées alone had the advantages and beauty of the scenery of Lord Street...'

The comparison with the Champs Elysées is interesting, as it has long been claimed that Lord Street provided the inspiration for the famous tree-lined boulevards of the French capital. Emperor Napoleon III was responsible for the transformation of Paris, which took place between 1854 and 1870. It is rumoured that some years before came to power, he spent some time in Southport.

Old and new shop signs on Lord Street.

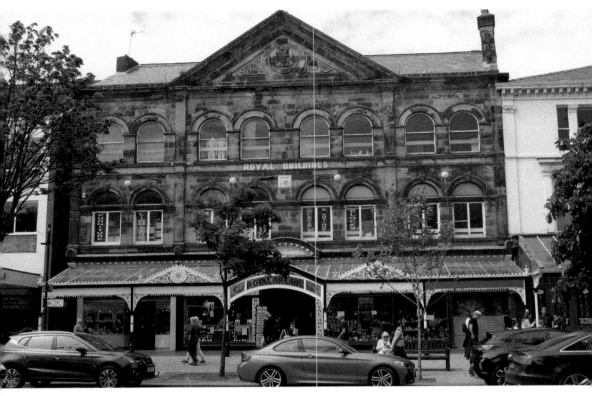

Above: Example of decorative iron and glass canopies on Lord Street.

Below: Early twentieth-century postcard showing Lord Street canopies.

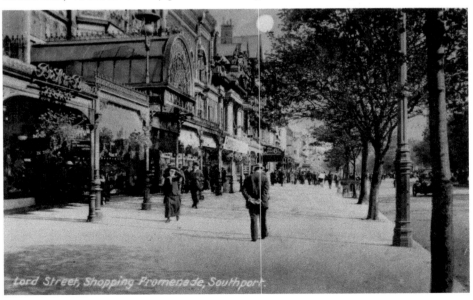

Born in 1808, Louis Napoleon was the nephew of Napoleon Bonaparte. Following the French defeat at the Battle of Waterloo, the whole family was forced into exile and for many years Prince Louis led a largely peripatetic existence, moving from one European country to another. He is believed to have visited Southport in 1838 and may even have rented a house for a short while close to Lord Street.

He subsequently returned to Paris and became Emperor in 1852. Soon afterwards, he began the project to rebuild the French capital city. Under the direction of Georges-Eugène Haussmann, its cramped medieval streets were demolished and replaced with wide tree-lined avenues. Southport fans have long claimed that the inspiration for Emperor Napoleon III's vision of a new Paris came from his memories of Lord Street.

By the early 1900s, many of the early two-storey buildings on Lord Street had been replaced by grand municipal buildings and commercial premises in a variety of architectural styles, of which more in Chapter 6. The architectural quality of the buildings reflects the importance of Lord Street as the civic and commercial hub of the town at a time when Southport was a highly prosperous seaside resort.

Over the years, not all of Lord Street's historic buildings have received the attention they deserve and some have undoubtedly suffered as a result of a lack of maintenance. The recently announced Southport Townscape Heritage project aims to restore some of the town's historic buildings to their former glory. Work is already under way at Nos 519–525 Lord Street to remove the shopfront from the 1980s and replace it with one of more traditional appearance, harking back to those years in the early twentieth century when Lord Street was its very finest.

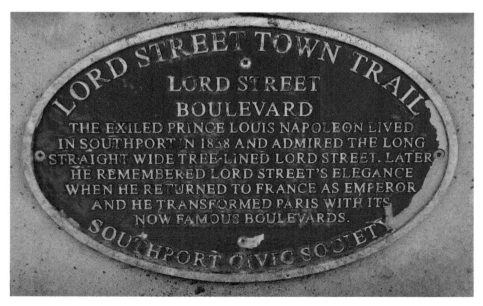

Emperor Napoleon III plaque.

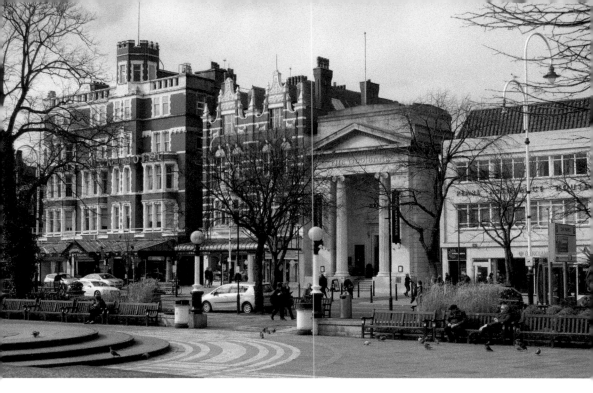

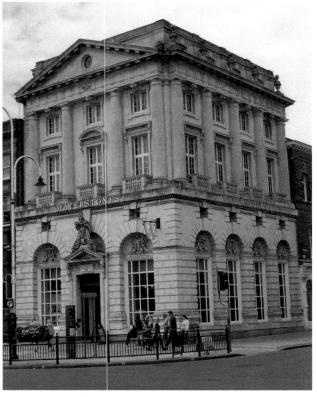

Above: Example of differing architectural styles on Lord Street.

Right: Another example of Lord Street's fine architecture.

More architectural features on Lord Street.

Significant People

Dr Miles Barton is probably not a name recognisable to most Southport residents today, but, as we saw in Chapter 1, the story goes that during a celebration held to mark the opening of William Sutton's hotel in 1798, he christened it the 'South Port Hotel' and the name of 'South Port' was soon applied to the developing resort.

Barton hailed from nearby Ormskirk and was known for being the owner of the 'Ormskirk Medicine'. Marketed as being 'more effectual than any other for the cure of a bite of a mad dog', this treatment for rabies had been originally developed by the late William Hill, also of Ormskirk, in the early 1700s. A 1782 newspaper advertisement for the Ormskirk Medicine boasted that 3,500 doses had been administered over the previous four years without a single failure. By the time that Louis Pasteur developed the first successful rabies vaccination a century or so later, the Ormskirk Medicine had long since been debunked as offering an effective cure for the disease. However, modern experts have suggested that the active ingredients in the medicine may have helped treat the actual bite wounds.

Not long after William Sutton's hotel opened in 1798, Barton built his own property, called Nile Cottage, nearby, making him one of the earliest permanent settlers in the new resort. In Barton's day, sea bathing was also commonly recommended as an effective treatment for rabies, so it seems highly probable that the good doctor would have been amongst those early trailblazers recommending the health benefits of sea bathing at South Hawes to his patients. As such, he may be considered a contributor to the new resort's early success.

By the mid-nineteenth century, some high-profile figures were visiting the resort. During the 1840s, the guest list for the exclusive Claremont House Hotel on the Promenade included the influential Lascelles family of Harewood House, as well as a future Prime Minister, the Earl of Derby. The popular American novelist Nathaniel Hawthorne, who is best known today for his 1850 historical novel *The Scarlet Letter,* also spent ten months in the resort from September 1856 to July 1857.

In 1853, Hawthorne had been personally appointed by US President, Franklin Pierce, to the position of American Consul in Liverpool. The Merseyside city was still a major international port at the time and the consulate position was regarded as highly lucrative, as well as prestigious. The Hawthorne family first lived on the

View of Promenade buildings.

Wirral Peninsula, but moved to Southport in the hope that the bracing sea air would benefit the health of Hawthorne's ailing wife, Sophia. They rented a cottage on the then fashionable Brunswick Terrace on the Promenade (sadly no longer in existence).

The family's sojourn in Southport is well-documented in a journal which Nathaniel Hawthorne kept throughout his time in England. Sad to say, it soon becomes apparent that he is not a fan of the place. Less than a month after his arrival, one journal entry reads: 'The country about Southport has as few charms as it is possible for any region to have.' In another entry, he complains that 'in all my experience of Southport I have never yet seen the sea'.

However, amidst all the barbed comments, his journal does provide an invaluable insight into life on the Sefton coast at the time. After commencing with a typically uncomplimentary remark, one entry from June 1857 offers a particularly detailed description of the type of entertainment on offer in the resort during the busy summer season:

> I never was more weary of a place in all my life, and never felt such a disinterested pity as for the people who come here for pleasure. Nevertheless, the town has its amusements ... the daylong and perennial one of donkey-riding along the sands ... *The Flying Dutchman* trundles hither and thither when there is a breeze enough; an arch cry-man sets up his targets on the beach ... the hotels have their billiard-rooms; there is a theatre every evening.

The street entertainers, who frequented the Promenade at the height of summer, included 'a man with a bassoon and a monkey', 'wandering minstrels, with guitar and a voice' and 'a Highland bagpipe ... together with a Highland maid, who dances a hornpipe'.

The Flying Dutchman, to which Hawthorne refers, was one of two sand yachts, along with the *Ariel,* which operated on Southport beach at the time. Carrying up to a dozen passengers each, the yachts were said to be capable of achieving speeds of up to 20 miles per hour and it seems that collisions with the bathing machines, which were also then in popular use on the sands, were not uncommon. Nevertheless, *The Flying Dutchman,* at least, remained in operation until the construction of the Marine Lake.

Hawthorne's journal also records a visit by another giant of American literature, Herman Melville, who came to stay with the family in late 1856. Melville, the author of the nineteenth-century classic *Moby Dick,* visited his old friend before embarking on a Grand Tour of Europe. Hawthorne's account reveals that the pair took a long walk, before sitting down in a sheltered spot amid the sand dunes to smoke cigars. It is not difficult to imagine Hawthorne complaining about the weather and the absence of the sea.

When a later literary visitor, Thomas Hughes of *Tom Brown's Schooldays* fame, came to the resort in March 1884, he was rather more appreciative of its attractions. He was particularly impressed by the expanse of golden sands:

At other seaside places the shallowness of the sand limits the pure delight of children in their castle-building. Here it seems boundless. I saw one sturdy

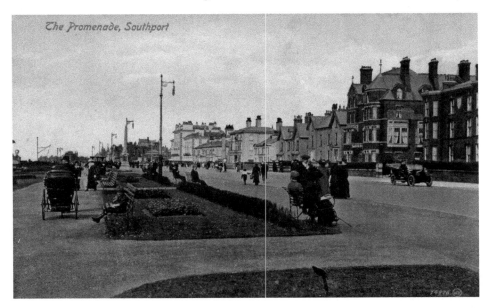

Vintage postcard of the Promenade.

urchin yesterday throwing out stoneless sand from a hole some four feet deep. The castles and engineering works are therefore on a splendid scale, several of them from five to ten yards across, inside which bits of old spars (portions, I fear, of wrecks) are utilised for causeways and bridges.

Hughes also praises the now sadly demolished 'most striking' St Andrew's Church on Eastbank Street, commenting that 'I was attracted to it by its good proportions, and the stone tracery of several of the windows, reminding one of the patterns of the early decorated period of Gothic art'. St Andrew's had been built only twelve years previously, but the church was evidently already in need of significant restoration work. 'The more's the pity', comments Hughes, 'in as much as the necessary closing of the church is going to shelve, probably for months, the most striking preacher I have heard this month of Sundays'.

The preacher in question was Revd Thomas Henry Cross, who was the church's first vicar. Such was his popularity with his parishioners that upon his death in July 1893, the congregation decided to pay for a memorial cross at the church in his honour.

One of Southport's greatest benefactors, William Atkinson, made a hefty contribution to the cost of building St Andrew's Church. He donated to several significant building projects around the town, most notably the Library and Arts Centre which still bears his name (of which more in Chapter 6). A wealthy cotton manufacturer who hailed from Knaresborough in Yorkshire, Atkinson fell in love with Southport after he and his ailing wife paid several visits to the resort in the hope that she would benefit from the sea air. He eventually moved to the town, purchasing the former Claremont Hotel on the Promenade as his home. This Grade II listed building, today known as Byng House, is now occupied by a residential care home.

Frederick Hooper, who died in Southport in June 1955, has an interesting claim to fame. He was a member of the search party who, in 1912, found the frozen body of the famous Antarctic explorer Captain Robert Falcon Scott, plus two other men, close to the South Pole.

Hooper was just nineteen years of age when, in 1910, he joined the Terra Nova Expedition to Antarctica. The primary purpose of the mission was to carry out scientific and geological research in the Antarctic region, but there was also the added incentive of becoming the first expedition to reach the geographic South Pole.

In January 1912, Captain Scott did successfully lead a party of five men to the South Pole, only to discover that a rival expedition, led by the Norwegian explorer Roald Amundsen, had beaten them to it by a matter of weeks. All five men perished on the return journey. Some eight months later, in November 1912, a search party, which included Hooper, finally discovered the bodies of Scott, together with Chief Scientist Dr Edward Wilson and Lieutenant Edward Bowers. The bodies of the two other men, Captain Lawrence Oates and Petty Officer Edgar Evans, were never found.

Above: The Atkinson, Lord Street.

Right: F. J. Hooper plaque.

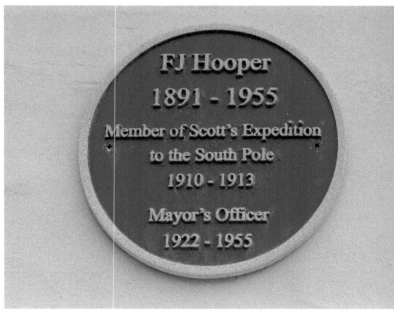

FJ Hooper
1891 - 1955
Member of Scott's Expedition
to the South Pole
1910 - 1913

Mayor's Officer
1922 - 1955

Following his return home, Hooper worked at Southport's Town Hall for over thirty years and a plaque on the wall there commemorates his contribution to the tragic Terra Nova Expedition.

Southport's Suburbs

In 1875, the previously independent village of Churchtown became part of the borough of Southport. The move, predictably, did not meet with universal approval. Its inhabitants were proud of Churchtown's long history and its place at the heart of the ancient parish of North Meols, and many did not take kindly to the village's absorption into the modern town of Southport, which had sprung up within its own parish boundaries.

To this day, Churchtown has retained much of its original old-world charm. Both the Hesketh Arms (where William Sutton was once the landlord) and the Bold Arms (previously known as The Griffin) are believed to date back to the latter part of the seventeenth century. The village is also known for its distinctive low single-storey white cottages, many with thatched roofs. Originally the homes of local fishermen, these cottages date from the seventeenth and eighteenth centuries, but their unusual appearance owes much to the older Viking tradition of turning old boats upside down to create a dwelling.

The current parish church of St Cuthbert's dates from the early 1700s, but there is believed to have been a church on the site since medieval times. An ancient tradition exists that St Cuthbert's coffin was brought to the area in the ninth century by monks seeking sanctuary after being compelled to flee their home of Lindisfarne when the island was invaded by the Vikings. The monks are said to have spent several years travelling around the north of England and southern Scotland before St Cuthbert was eventually laid to rest in Durham Cathedral.

Many early nineteenth-century visitors to Churchtown headed to the Strawberry Gardens, where they were served with strawberries and cream in what one slightly underwhelmed customer once described as 'dismal little alcoves or summerhouses'. In 1874, a grand new attraction opened on the same site. The Botanic Gardens included a large serpentine lake, complete with a boathouse and ornamental bridges, a grand glass conservatory, fernery and menagerie/aviary.

Two years later, the Botanic Gardens Museum opened its doors for the first time. One reporter noted that the museum's collections included 'natural history, geology, coins, medals and curiosities'. The great P. T. Barnum (whose connection with Southport we shall explore more fully in Chapter 9) is said to have acted as

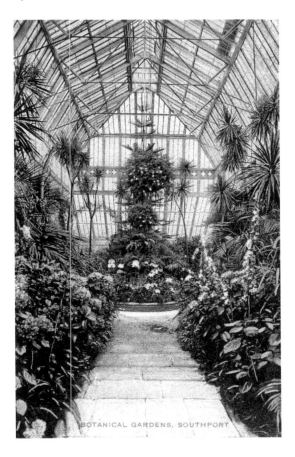

Botanic Gardens postcard.

an advisor in setting up this new enterprise and for many years one of his top hats was a popular exhibit.

When, in 1932, the land was acquired by a private investor, it seemed that the once beautiful Botanic Gardens were going to be replaced by a new housing development. Fortunately, this plan never came to fruition. In 1936, the site was purchased by Southport Corporation and the Botanic Gardens was reopened to the public the following year.

In recent times the Botanic Gardens and Museum have once more been threatened with closure because of cutbacks in spending by Sefton Council. The museum remains closed, but over the last decade a group of local volunteers have done sterling work in ensuring that the gardens have continued to remain open by planting new flowers and shrubs and carrying out essential gardening and maintenance work. Let's hope that their hard work will be rewarded following the recent announcement of a major new development scheme to secure the future of this still much-loved visitor attraction.

Like Churchtown, the history of Birkdale and Ainsdale stretches much further back than that of Southport itself. When these two townships became part of the

borough of Southport in April 1912, it led to a significant extension of its borders and has played a significant part in the development of the modern-day resort.

Birkdale today enjoys a reputation as a prestigious residential suburb, but it has not always been held in such high regard. There is believed to have been a small settlement in the area since around the time of the Norman Conquest. In 1834, a writer named Edwin Butterworth described it as 'a cheerless, bleak, forlorn little region partly occupied by sandhills and meagre pasture grounds'. A rare example of one of Birkdale's early cottages survives to this day on Liverpool Road.

Only a few years after Butterworth's less than flattering description of the area was published, the land around Birkdale was inherited by Thomas Weld Blundell. No doubt, noting the success of the rapidly expanding new resort of Southport just down the road, the new landlord was quick to see the possibilities of developing Birkdale on similar lines, particularly when work began on the new Southport to Liverpool railway line in 1848. Having secured the necessary Act of Parliament, plans were drawn up to develop a residential area on the stretch of land adjacent to the border with Southport.

A report in the *Liverpool Mercury* from October 1848 noted that 'the proprietor of the township of Birkdale ... is willing to grant long leases for building purposes, on liberal terms. The township will be laid out under the superintendence of eminent surveyors and landscape gardeners, so that the plans will meet the views as well of those who would wish to possess marine residences of considerable extent, as of those who would desire to erect single houses or shops'.

John Aughton, a builder and entrepreneur who had recently moved to the area from Preston, was one of the first to become involved in the new development. The foundations for his first property on Lulworth Road in Birkdale were laid in August 1850. Aughton went on to build a series of fine villas in Birkdale Park and such was his perceived influence on the new development that when, in 1854, he left to work on a fresh project in Canada, a special dinner was held in his honour at Southport's Victoria Hotel. The *Southport Visiter* reported that Aughton was lavishly praised for commencing 'the formation of a new town', with the speaker adding that 'I do not believe there would have been a single brick or stone laid in Birkdale Park had it not been for him, to this day'.

As the number of residential properties grew, so did the area's facilities. Birkdale's first church, St James', was consecrated in 1857, followed by Roman Catholic church St Joseph's a decade or so later. Birkdale's fine Town Hall was opened in 1872, followed, in 1905, by a public library, one of many throughout the country to be funded by philanthropist Andrew Carnegie.

In 1866, a grand new hotel, the Palace, was built on a 20-acre site, close to the seafront, at a cost of some £60,000 (which equates to around £7.5 million today). From the start, the hotel struggled and, in 1881, was compelled to go into liquidation. After a significant refurbishment and equipped with all the mod-cons expected of a late Victorian upmarket retreat, the Palace was reopened as a luxury spa hotel.

The Palace attracted some famous guests over the years. Judy Garland and her entourage occupied three suites there, while she was appearing in Liverpool and Manchester. Frank Sinatra is known to have stayed at the Palace for five nights in 1953, whilst performing at the Liverpool Empire.

During the Second World War, the Palace was requisitioned by the Red Cross and used as a convalescent home for wounded U.S. servicemen. Some of the injured troops there were filmed for a documentary called *Combat America,* which was narrated by another Hollywood great, Clark Gable, and he is known to have visited the hotel during the film's production.

Despite attracting its fair share of glamorous visitors, the Palace appears to have faced a constant battle to fill its rooms with paying guests. By the time that the Birkdale Palace closed its doors for the final time in 1967, there were said to be a mere two guests staying at the hotel. The building's final hurrah came when it was used as a location for films starring Boris Karloff and Norman Wisdom. It then fell into disuse and, in 1969, despite local opposition, was demolished. Today, the Fishermen's Rest pub, which was once occupied by the Palace's coach house, is all that remains of this once elegant hotel.

Sadly, Birkdale's fine civic buildings, considered surplus to requirements once the township became part of Southport, were demolished in 1971. However, Birkdale has retained much of its own identity. At its heart is Birkdale Village on Liverpool Road, which, with its tree-lined pavements and ornate shop awnings, bears more than a passing resemblance to Lord Street. Birkdale's glass canopies are a little

Fishermen's Rest, Birkdale.

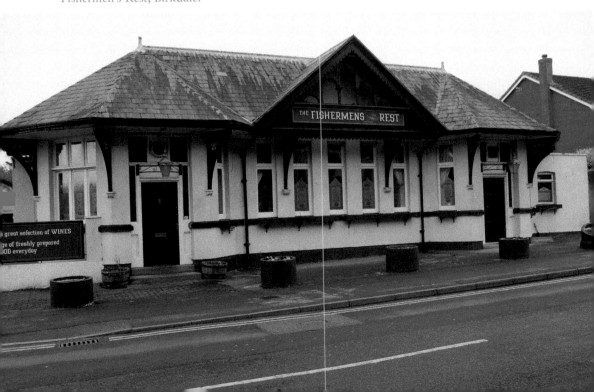

later in date than those on Lord Street and appear to have been installed as a deliberate attempt to emulate one of Southport's most noteworthy features. With its variety of independent shops, bars and restaurants, Birkdale Village remains a popular destination for visitors today.

Located about 3 miles south of Southport, the history of Ainsdale, like Birkdale, dates back more than 1,000 years. The land on which the present-day Ainsdale is situated even merits an entry in the Domesday Book of 1086 as 'Einulvesdel', literally meaning 'the valley occupied by Einulf' (presumably a Norseman who settled in the area).

Until the arrival of the railway in the mid-nineteenth century, Ainsdale was primarily a small agricultural community and even then its development as a residential village did not proceed at the same pace as its neighbour, Birkdale. However, by the time that it became part of the county borough of Southport in 1912, the heart of the Ainsdale community inland from the railway line had developed to a point which would be recognisable to residents today.

The increase in the number of people owning their own cars from the 1950s onwards had a significant impact on property development in Ainsdale. It became a popular place to live with commuters travelling to work in Liverpool and many new houses were built during the 1960s and 1970s. Indeed, this explains my own connection with Ainsdale, as we moved to the area in late 1969 when my father started a new job based in Bootle.

The Ainsdale of today is a thriving suburb of Southport, but, like Birkdale, has still managed to retain much of its village community feel.

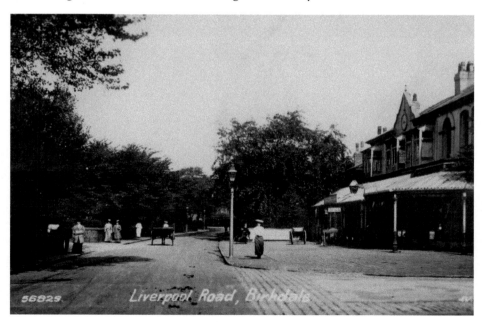

Early twentieth-century postcard of Liverpool Road, Birkdale.

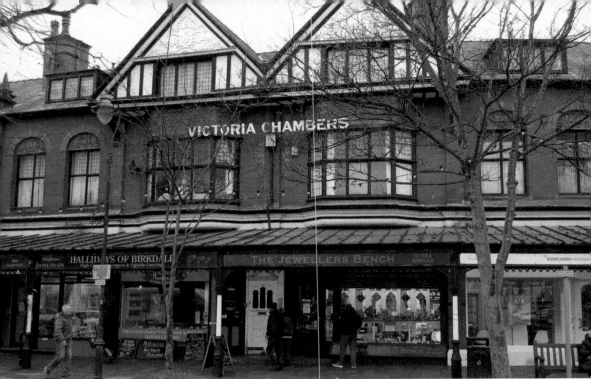

Above: Birkdale village.

Right: Birkdale's ornate shop awnings.

Above: Ainsdale.

Below: Community garden and church in Ainsdale.

As we shall discover in subsequent chapters, the vast expanse of unbroken sands at Ainsdale Beach proved a magnet to early aviators and motor racing pioneers. Today, the beach is regarded as one of the best destinations in the UK for extreme kite activities, with special zones set aside on the sands for kite buggy and landboard use, as well as kitesurfing out at sea.

In 1890, the then landowner, Charles Weld Blundell, announced an ambitious plan to develop the land near to the beach into an upmarket residential area featuring homes on a grand scale. He may have been inspired by his father, Thomas, who had instigated the scheme to turn Birkdale into a residential suburb during the mid-nineteenth century. However, Weld Blundell Junior's scheme failed to excite the imagination of prospective investors and eventually it was abandoned in favour of a more modest scheme to create a 'seaside garden village'.

A newspaper feature from 1908 noted that 'the aim of the promoters is to provide small artistic houses on plots of land one-eighth of an acre in extent, with a reasonably low ground rent'. The scheme aimed to interest retired people who wished to live near the sea, or families able to afford a small holiday home at the coast. This new strategy did meet with more success, with the *Southport Visiter* reporting in 1911 that 'this portion of Ainsdale is now being well-populated'.

Although Charles Weld Blundell's grand plans for his residential development at the Ainsdale seafront never came to fruition, the area has always attracted day trippers. Following Southport Corporation's acquisition of the Ainsdale foreshore in the interwar years, a popular lido was built there. Facilities included a café with an open-air terrace, changing rooms, showers, wooden chalets and tennis courts. During the Second World War, much of the Ainsdale seafront, including the Lido, was taken over by the Royal Navy and used as a gunnery school, known as HMS Charlotte.

The Ainsdale Discovery Centre is now situated on the spot once occupied by the Lido. The area of sand dunes over which Charles Weld-Blundell once proposed to build his grand residential development has, in the modern era, become part

Toad Hall mural by Paul Curtis.

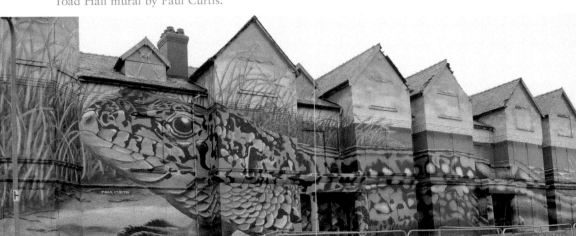

of a nationally important nature reserve. The Ainsdale and Birkdale Sandhills Local Nature Reserve is one of the largest areas of wild dunes left in the British Isles. Established in 1980, it is home to a diverse range of rare species including the natterjack toad, great crested newt and sand lizard. Some of the country's rarest wildflower species may also be found on the reserve including the dune helleborine and seaside centaury.

In September 2021, a colourful artistic tribute to the Sefton coast's rare sand lizard was unveiled in the form of a gigantic mural on the exterior of the former Toad Hall building next to Ainsdale Beach. Created by award-winning Merseyside street artist Paul Curtis, this spectacular artwork has transformed the area and is hoped to be the first in a series of projects intended to revitalise this section of the coastline.

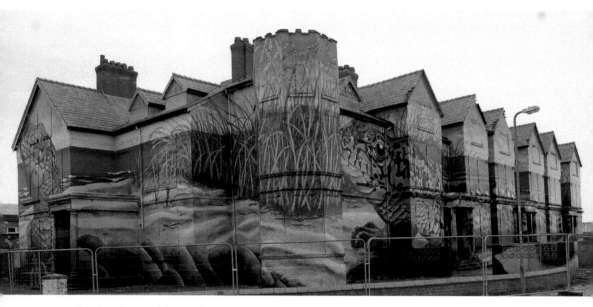

Toad Hall mural by Paul Curtis.

Notable Landmarks

Wellington Terrace, at the southern end of Lord Street, was mentioned in Southport's entry for the 1820 *Guide To All The Watering and Sea Bathing Places* and is still going strong today, making these properties the oldest surviving buildings on the resort's famous thoroughfare. Built in 1818, the terrace of eight houses was named in honour of the Duke of Wellington, whose heroics at the Battle of Waterloo were still fresh in the mind, having taken place only three years previously. The houses were originally fishermen's cottages, which, in 1818, were substantially extended and refronted in the then fashionable Regency style. Now Grade II listed buildings, they are still used as private residences today.

Wellington Terrace.

In 1852, work commenced on the Town Hall, which was the first in a series of impressive public buildings to be constructed on the east side of Lord Street during the second half of the nineteenth century. The Town Hall has been extended on several occasions to the rear, but its white-stuccoed façade, which is perfectly symmetrical, has remained largely unchanged since the day it was built.

The building's design owes much to the then fashionable Palladian style of architecture, whose origins lie in the work of sixteenth-century Italian Renaissance architect Andrea Palladio. Palladio was inspired by the classical temples of ancient Greece and Rome, and it is possible to see these influences in local architect Thomas Withnell's design for Southport Town Hall. The entrance, with its central stone staircase leading up to a porch flanked by fluted Doric columns, would not look out of place in an early Greek temple.

At the top of the building is a central triangular pediment, which is embellished with carved figures symbolising Justice, Mercy and Truth. These figures represent the Town Hall's original functions. As well as being occupied by Southport's Improvement Commissioners (whom we met in Chapter 3), the building also housed the police station and magistrates' court. Some of the original Victorian prison cells, which were situated beneath the Town Hall's grand staircase, have survived to this day.

Separated from the Town Hall by the Cambridge Arcade, The Atkinson is an impressive arts centre, of which the town is rightly proud. Following a major

Town Hall.

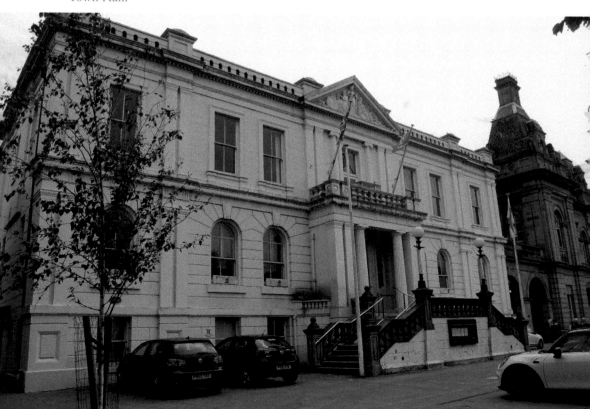

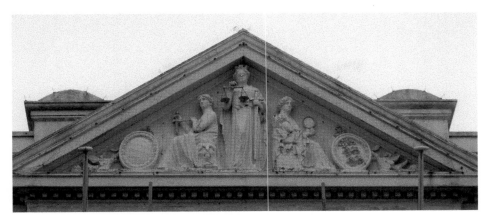

Town Hall's triangular pediment.

three-year redevelopment project, the venue reopened in its current form in 2013 and is now home to a theatre, museum, art gallery and café, as well as Southport Library. The Atkinson has its origins in two imposing sandstone buildings that were constructed during the 1870s.

The Atkinson Library and Art Gallery, which now forms part of the modern arts complex, was first opened in 1878. It was named in honour of Southport's great benefactor, William Atkinson, who personally donated £6,000 towards the cost of the town's first purpose-built free library and art gallery.

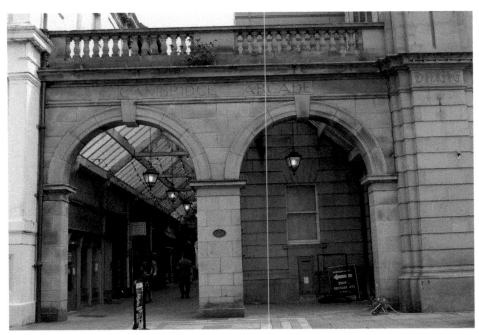

Cambridge Arcade.

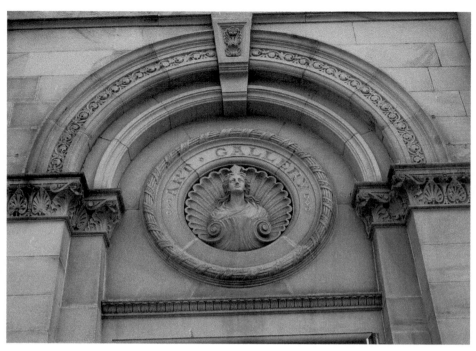

Art Gallery decorative roundel.

Atkinson Library vintage sign.

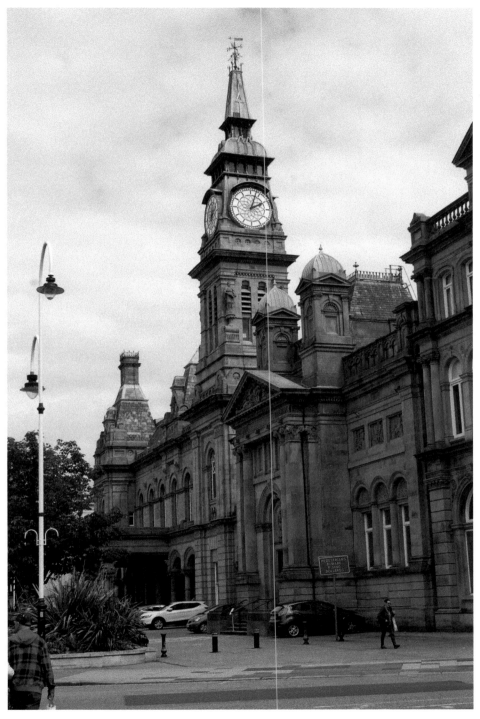

Atkinson building.

The other part of the modern building was formerly known as Cambridge Hall. Not one, but two, impressive new entertainment venues were opened in Southport in late 1874 – an ambitious private venture called the Winter Gardens (of which more in Chapter 9) and the publicly funded Cambridge Hall. The foundation stone for the latter was laid by Princess Mary of Cambridge (the mother of the future Queen Mary, wife of King George V) in October 1872 and it was subsequently named in her honour.

The tall clock tower to the right of the building still serves as an impressive focal point today. The four carved figures, one at each corner of the tower, were the work of Liverpool sculptor Alfred Norbury. They represent four notable leaders, or 'guardians of time', connected with British history, namely Caractacus (an early British chieftain), Julius Caesar (the Roman statesman and general), Alfred the Great (the famous ninth-century monarch) and Edward the Confessor (the last great Anglo-Saxon king to rule England before the Norman Conquest).

In 1903, two years after the death of Queen Victoria, an imposing bronze statue on a high stone plinth was unveiled in front of the then Cambridge Hall. In the work by the world-renowned sculptor Sir George Frampton, Queen Victoria is featured holding the sceptre and orb that form part of the Crown Jewels.

Southport Corporation originally intended to position the statue near the Promenade, but was compelled to amend its plans after a public outcry regarding the unsuitability of placing a statue of the nation's highly esteemed former monarch in such an 'unrespectable' spot, which was considered to be the hub of

Atkinson clock tower.

rowdy behaviour in the resort. The outrage proved short-lived and, in 1912, the statue was moved from Lord Street to its present site in Nevill Street, where it was placed facing the sea.

In 2006, the statue was temporarily removed for some much-needed restoration work and when it was subsequently reinstalled, it was turned round to face the Monument on Lord Street. This was purposely done to link the Queen Victoria statue in a straight line to the town's imposing war memorial.

Southport's Monument, which occupies a prominent central position at the heart of Lord Street, was constructed in the early 1920s. Following the end of the First World War, a public appeal was launched to raise funds for a war memorial in honour of the Southport servicemen and women who had lost their lives during the conflict. Architects were invited to submit plans in an open competition and the winning design was the work of the Liverpool partnership Grayson & Barnish.

Work on the memorial was initially delayed because of a shortage of skilled stonemasons, but it was finally unveiled in 1923 on Remembrance Day. During the ceremony Southport's then Mayor, Alderman Charles Aveling, declared that 'Hitherto this place has been known as London Square. From henceforth let it be called The Monument' and this is how it has been known locally ever since.

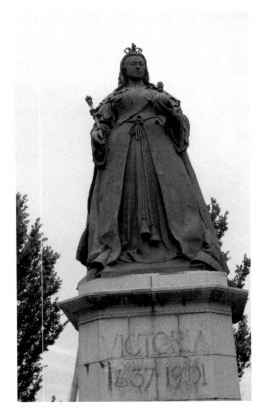

Queen Victoria statue.

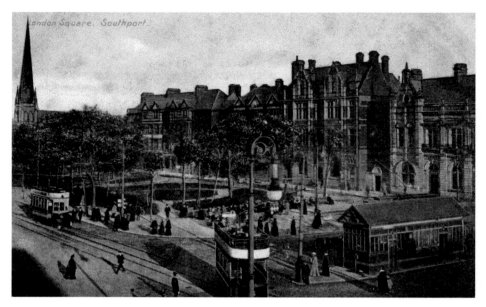

The former London Square.

Southport's war memorial is exceptionally grand for a town of its size and there are few that would argue with the view expressed in *Seed's Southport & District Directory* of 1933/34 that 'the erection of the Monument ... has added further to the architectural beauty of the thoroughfare'. Its elaborate design in Portland stone consists of a tall obelisk over 20 metres high, which is flanked on either side by two colonnades in the style of ancient Greek temples. The names of those local men who lost their lives during the 1914–18 war are inscribed on the walls of the chapels, which are situated at each end of the two colonnades. Further panels were later added to the walls to commemorate those lost during the Second World War and subsequent conflicts.

Harold Ackroyd, who is commemorated on Southport's Monument, was awarded the Victoria Cross, the nation's highest award for gallantry. Born in the town in July 1877, he had trained as a doctor at Cambridge University. Having enlisted in the Royal Army Medical Corps in 1915, Captain Ackroyd was compelled to take sick leave in 1916 because he was suffering from nervous exhaustion. This makes the bravery of his actions the following year on the first day of the Battle of Passchendaele, for which he was posthumously awarded the Victoria Cross, seem even more remarkable. *The London Gazette* reported that 'Utterly regardless of danger, he worked continuously for many hours up and down and in front of the line tending the wounded and saving the lives of officers and men. In so doing he had to move across the open under heavy machine-gun, rifle and shell fire ... His heroism was the means of saving many lives'. On 11 August 1917, only eleven days after his heroic actions at Passchendaele,

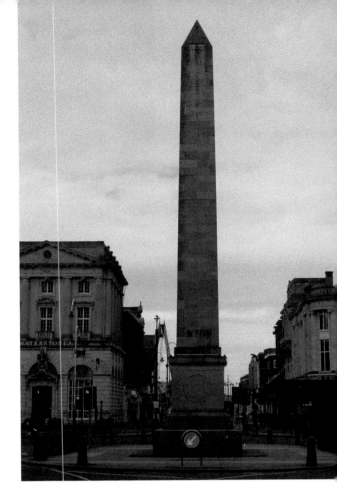

Right: Obelisk that forms part of Southport's Monument.

Below: One of the Monument's colonnades.

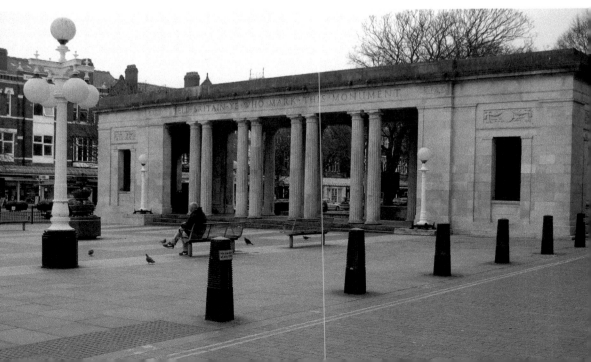

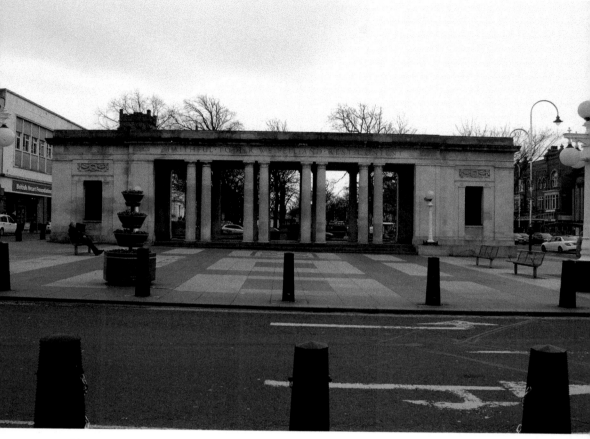

The second colonnade.

Harold Ackroyd was shot and killed whilst once again tending casualties in the most perilous of conditions.

The names of three local women who were killed on active service during the First World War also appear on the Monument.

Janet Lois Griffiths, the daughter of a former mayor of the town, was serving in Egypt as sister-in-charge of the officer's ward at Alexandria General Hospital when an ambulance in which she was travelling was hit by a train. She was killed whilst attempting to save her fellow nurses. Mary Gartside-Tipping joined the Women's Emergency Canteens Service in January 1917 and was on active service in France when only two months later she was accidently shot and killed by a French soldier. Nellie Taylor from Birkdale was killed in June 1918 while on active service in France with the Field Ambulance Service.

The Monument is surrounded by gardens on either side, each with its own long rectangular Pool of Remembrance and fountains, and these still provide a tranquil spot to reflect for a while amidst the hubbub of the busy town centre.

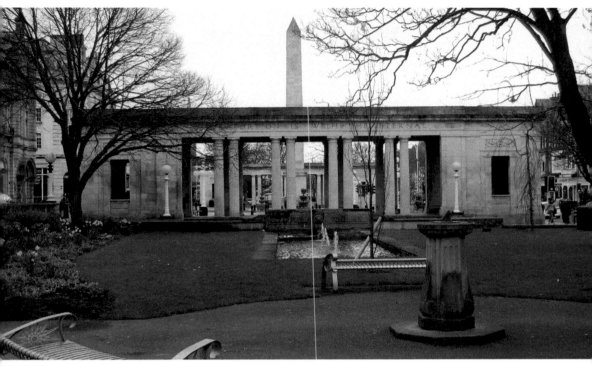

Above: Monument garden.

Below: Pool of Remembrance.

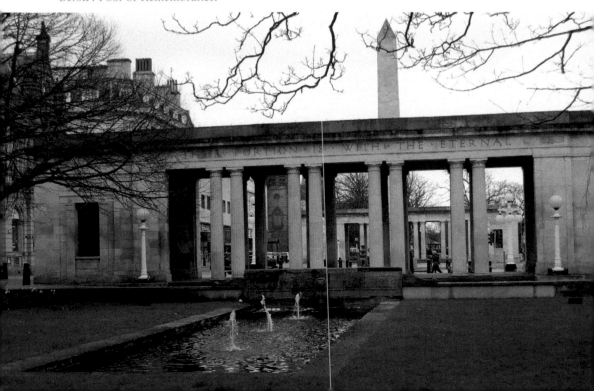

Sporting Connections

Just as Ainsdale Beach is today a popular destination for lovers of extreme kite sports, the area's wide sandy beaches have long attracted devotees of a variety of other sporting activities to the resort.

The Hesketh Golf Club, which is situated on the wonderfully named Cockle Dick's Lane, was established way back in 1885, at a time when the sport was beginning to gain popularity. It is hardly surprising that golf arrived in Southport relatively early on in its development as a leisure activity, as the area's distinctive sand dunes provided the perfect location for a links course.

More golf courses were established in the area over the following three decades, notably Birkdale (1889), Southport & Ainsdale (1907) and Hillside (1912).

Ainsdale Beach.

During the 1920s, Southport Corporation decided to join forces with the local clubs to promote the town as a major golfing venue, a marketing strategy that has continued to the present day. Southport is still heralded as the capital of 'England's Golf Coast'.

The breakthrough came when, in 1933, the Southport & Ainsdale Club was chosen as the venue for the Ryder Cup match between Great Britain and the United States. Now one of golf's most anticipated events, the contest was admittedly still in its infancy at the time (the 1933 match was only the fourth occasion on which the Ryder Cup had been held). However, the event still attracted huge media coverage, helped by the arrival of the Prince of Wales (the future King Edward VIII) to watch the second day's action and to present the trophy to the victorious British team.

The Ryder Cup returned to the Southport & Ainsdale Club four years later, when the American team won for the first time on British soil.

Not to be outdone by its near neighbour, Birkdale Golf Club opened a distinctive new clubhouse in July 1935. Its architect, a local man named George Tonge, had previously worked on the town's Garrick Theatre (see Chapter 10) and his clever use of the then fashionable art deco style is evident in both buildings. Tonge attributed his inspiration for the clubhouse's design to 'the lines of a liner at sea'. The *Lancashire Evening Post* described it thus:

> The building is in the form of a ship, with the storeys rising like decks, and the walls bulging in the middle from elongated ends. Non-golfers are even catered for in the many amenities provided. There are special facilities for sun-bathing on the two promenade decks which overlook the last hole, in one corner of which it would be possible to have a game of deck tennis. Downstairs in the lounge special sun-trap windows have been fitted. The interior decorations and fittings are considered the last word...

This followed a radical redevelopment of the Birkdale course, spearheaded by one of the sport's most respected course architects, F. G. Hawtree, together with golfer J. H. Taylor, who had captained the victorious 1933 Ryder Cup team.

When, in 1939, it was announced that Birkdale would host the following year's Open Championship, it appeared that the club's redevelopment programme had paid dividends. In the event, the 1940 Open Championship never took place because of the outbreak of the Second World War and Birkdale did not host its first Open until 1954. By this stage the club was known as 'Royal' Birkdale, having been officially awarded 'royal' status by King George VI in recognition of its increasing importance in the sport.

Since hosting its first Open Championship in 1954, Royal Birkdale has hosted the tournament on nine further occasions, including the prestigious 100th Open in 1971. Along the way, it has provided golf fans with some of the sport's most memorable moments. Past winners at Birkdale include the

legendary U.S. golfers Arnold Palmer, Lee Trevino, Tom Watson and, most recently, in 2017, Jordan Spieth.

Whenever the Open Championship comes to Southport, visitors arrive from all over the world and the town receives the kind of global media attention that makes it the envy of many of its competitors. Golf remains a key component in Southport's continued success as a holiday destination.

Back in the early days of the resort, an annual popular horse race meeting was held on the sands in conjunction with a sailing and rowing regatta. The Southport Gala Week, as it came to be known, attracted huge numbers of visitors to the town, but it became increasingly unpopular with residents who were unhappy with the disturbance it caused and, in some cases, the undesirable characters it attracted. The event was held for the last time in 1853, following which the then lords of the manor, Charles Hesketh and Charles Scarisbrick, were persuaded to exercise their 'manorial rights' to have the races abolished. This represents a classic example of the underlying tension at the time between the town's wealthy residents, who wished to portray themselves as living in an upmarket health resort, and those who, out of economic necessity, were more mindful of attracting holidaymakers to the town.

With the advent of the motor car, Southport became a popular venue for motor racing during the early years of the twentieth century. By this stage there was a much greater awareness of the importance of attracting visitors to the resort and the sport of motor racing, which was still very much in its infancy, proved to be a great money-spinner.

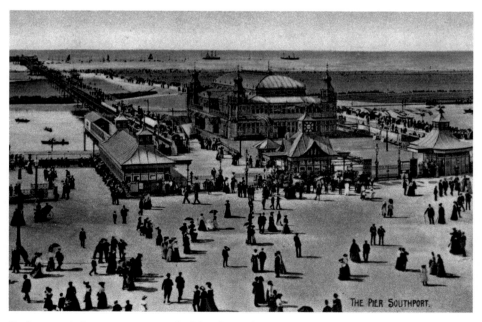

Early twentieth-century postcard of Southport Pier.

The Southport Motor Club, which was formed in 1902, was responsible for organising many of the races in the town. In July 1903, the Southport Speed Trials, one of the earliest motor sport meetings to be held there, attracted much coverage in the national press. One of the races was won by a woman, Dorothy Levitt, who worked as a secretary at the Napier Car Company. Company Director Selwyn Edge had come up with the idea of entering her for the race, believing that it would be a good publicity stunt to have a young woman drive one of the company's cars. Little could have he dreamt that she would win the race (to the delight of a crowd of an estimated 50,000 people) and go on to be one of the leading names in the sport.

In the early days, Southport Promenade was the location of choice for street races and speed trials, before the course was expanded to form a circular route which took in Lord Street. As time moved on, the need to close roads for long periods became an issue, so the decision was taken to move to the sands. By the late 1920s, the events, which usually featured races for cars, motorcycles and three-wheelers, attracted huge crowds.

In January 1926, Major Henry Segrave was one of the competitors taking part in the Southport Speed Trials. The daring Segrave had served as a fighter pilot in the Royal Flying Corps (the forerunner to the RAF) during the First World War, before subsequently becoming one of the leading figures in the emerging sport of

Lord Street pub named in honour of Henry Segrave.

motor racing. In 1923, he had the distinction of becoming the first Briton to win a Grand Prix, when he was victorious at Tours in France.

Segrave had a successful time, winning all four races that he entered, and two months later returned to the area to launch an attempt on the land speed record. In his 4-Litre Sunbeam Tiger, which was nicknamed the *Ladybird*, he achieved a then world record speed of just over 152 mph on the stretch of beach between Birkdale and Formby. His record was surpassed only a month later, but Segrave subsequently regained the record at Daytona Beach in Florida.

Only four years after his success at Southport, Segrave was tragically killed whilst in pursuit of another record. He successfully achieved a new water speed record on Lake Windermere, but his boat, *Miss England II,* capsized at full speed during the attempt and, despite being dragged from the wreckage, Segrave died of his injuries shortly afterwards.

Probably the most prestigious meeting ever to be held in Southport took place in June 1928 when a 100-mile race for cars was held on Birkdale Beach. The event attracted the top motorsport stars of the day including the legendary Sir Malcolm Campbell and was said by one newspaper report to be 'the biggest race held in England outside Brooklands' (the only motor racing circuit in Britain at the time). It is estimated that as many as 100,000 spectators may have attended the race that day.

The Southport meeting presented the drivers with an entirely different challenge to racing on the concrete oval banked circuit at Brooklands. The course included several bends, including a tricky hairpin. The drivers had to contend with the constant churning-up of sand at the bends and this led to tragedy when the car driven by a well-known woman racer of the time, May Cunliffe, crashed and overturned at the hairpin bend. She survived the crash, but her father Alfred, who was riding alongside her as mechanic, was killed.

In October 2021, memories of those brave motor racing pioneers who competed on Southport's golden sands were revived when a special festival, celebrating the resort's historic connections with the early days of motorsport, was held at Victoria Park. It is hoped that 'Southport Classic and Speed' may become a regular fixture in the resort's calendar of special events.

During the 1970s, the resort's famous sands played a key role in the career of one of the UK's favourite sporting heroes, a racehorse who to many remains the greatest ever. The incomparable Red Rum is now so closely associated with the town and his Birkdale-based trainer, Ginger McCain, that it may come as a surprise to discover that he was, in fact, born across the water in County Kilkenny in the Irish Republic. The horse arrived in England as a one-year-old in 1966 but did not team up with the trainer who would make him famous until six years later.

Part-time trainer Donald 'Ginger' McCain had been involved with training horses since the early 1950s, but only on a small scale. He used stables that were situated behind his second-hand car business on Upper Aughton Road in

Birkdale and worked as a taxi driver to supplement his income. Through his taxi work he became acquainted with Noel Le Mare, an elderly local businessman who was accustomed to attending a dinner dance at the Prince of Wales Hotel every Saturday night. As McCain ferried him there in his taxi each week, the pair would chat about racing. Le Mare had long harboured an ambition of owning a Grand National winner and when Red Rum was put up for auction at Doncaster's August 1972 sales, the trainer persuaded Le Mare to let him buy the horse on his behalf.

The early signs were not all that promising. When Red Rum first arrived at the stables, he appeared lame and was diagnosed as suffering from an incurable inflammatory bone disease called pedal osteitis. As a young boy, McCain had witnessed first-hand the restorative effects of the sea on the old horses used by the shrimpers working on the coast at Southport and so he decided to take Red Rum for a dip in the sea. Soon the salt water of the Irish Sea began to work its magic and the horse's lameness had gone. The beach became Red Rum's training ground. McCain would prepare a stretch of sand between Birkdale and Ainsdale, ensuring the sand was smooth and clean by using a harrow attached to the back of his van.

Red Rum won his first five races under his new owner and trainer, and, as the 1973 Grand National approached, he was installed as joint favourite alongside Crisp.

The 1973 race is now considered to be one of the greatest Nationals of all time. By Becher's Brook on the second circuit, Crisp had built up a significant lead of over 20 lengths. As he jumped the final fence, Crisp was still over 10 lengths clear,

Prince of Wales Hotel sign.

but, at a considerable weight disadvantage to his biggest rival, the gallant horse began to tire and Red Rum memorably thundered past him just yards from the line to win the race in a then record time of 9:01.9 minutes. Octogenarian Noel Le Mare's lifelong ambition of owning a Grand National-winning horse had finally been fulfilled.

A year later Red Rum won again, beating L'Escargot by 7 lengths, even though this time it was he who carried the top weight of 12 stones. He followed this success up with victory at the Scottish Grand National only three weeks later, thereby becoming the only horse ever to win both races in the same year.

Red Rum continued his remarkable run at Aintree, finishing second in both the 1975 and 1976 Grand Nationals. However, as the 1977 race approached, a historic hat trick of Grand National wins appeared increasingly unlikely, with the view commonly expressed that the twelve-year-old veteran was now too old to win the race. Red Rum famously proved the doubters wrong. Much to the delight of an adoring Aintree crowd and the watching millions at home, he romped home 25 lengths clear of the field. He was retired from racing the following year, but remained a regular visitor to Aintree, usually being at the head of the Parade of Champions preceding the big race.

Subsequently, in search of more room, Ginger McCain moved his stables to the Cheshire countryside and this was where, in October 1995, Red Rum died peacefully at the grand old age of thirty. In a fitting tribute to the Grand National legend, he was laid to rest near the winning post at Aintree.

Red Rum may have ended his days in retirement in leafy Cheshire, but he has never been forgotten by the town in which he lived for many years. The Wayfarers Arcade on Lord Street has been home to a bronze sculpture of the legendary horse since 1979. More recently, a mural of Red Rum by artist Paul Curtis has been unveiled on the side of a building at the top of Scarisbrick Avenue next to the Promenade. The huge mural, which depicts Red Rum galloping through the sea on Southport beach, makes a fitting tribute to this iconic horse.

As for trainer Ginger McCain, he proved wrong all the critics who dismissed him as a one-horse wonder by training another Grand National winner, Amberleigh House, in 2004. Two years later he retired, handing over control of the stables to his son Donald. Ginger McCain lived long enough to see his son train his own National winner, Ballabriggs, before eventually passing away in September 2011.

Southport FC may rightly be regarded as one of the very first English football clubs to embrace the commercial opportunities offered by the popularity of the nation's favourite sport. In 1918, the club is believed to have become the first in the country to take a sponsor's name when it was renamed as Southport Vulcan following its acquisition by the local Vulcan Motor Company. The company's association with the club did not last long, but further success soon followed.

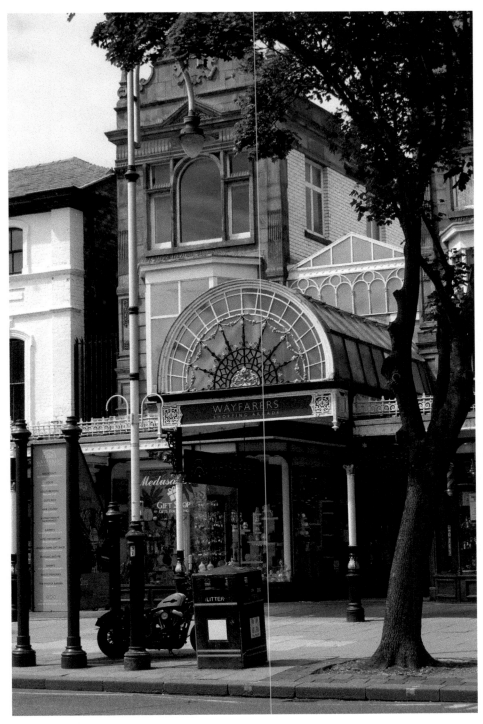

Wayfarers Arcade.

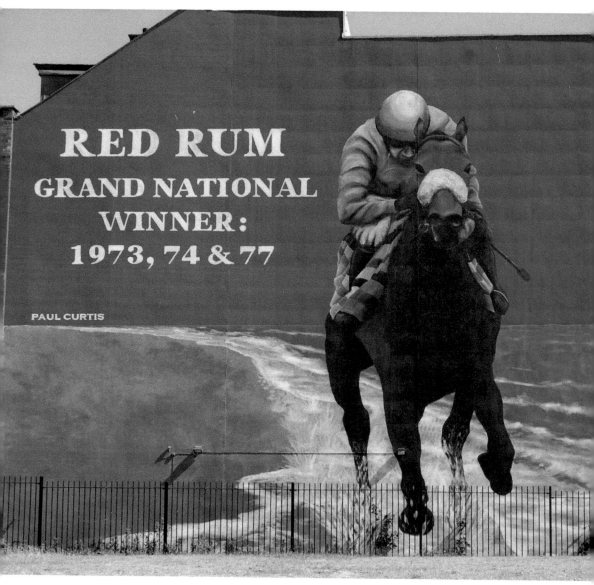

RED RUM

GRAND NATIONAL
WINNER:
1973, 74 & 77

PAUL CURTIS

Red Rum mural by Paul Curtis.

In its early days the Southport Football Club team played rugby union, but switched to association football during the autumn of 1881. In a report of one of the club's early games under association football rules, the *Southport Visiter* commented that, 'The team will no doubt render a good account of themselves when they get over the difficulty of hands off and forget the rugby rules.'

In 1888, soon after the formation of the Football League, the decision was taken to form a semi-professional football club in the town and Southport Central, as it was then known, entered the FA Cup for the first time during the following season. Then playing on Scarisbrick Road, the non-league club's annual end-of-season friendly against Preston North End, who were at that time one of the country's leading league clubs, was always highly anticipated. The clubs' meeting in April 1897 proved particularly memorable for the home side, as reported in the *Sporting Life*:

> The Preston North End paid their annual visit to the Scarisbrick Road Ground of the Southport Central Club on Saturday, and made an exhibition of themselves which would have disgraced a number of schoolboys. They played practically their League team, and yet were completely beaten by the Lancashire Leaguers. There were 3000 spectators present when North End started against only ten men on the Southport side. This slight disadvantage, however, made no difference with the visitors, for they played such shockingly poor football that the home side had no difficulty in keeping them in check ... Result: Southport Central, six; Preston North End, one.

The club moved to its current home of Haig Avenue in 1905. Three years later, the ambitious Edwin Clayton was appointed as the club's new Secretary. Only months after Clayton's appointment, Southport was one of five clubs which applied to join the Football League, but failed to register a single vote and the place, instead, was offered to Tottenham Hotspur.

Southport made several more applications to join the Football League, all of which ended in failure, until, in 1921, soon after its association with the Vulcan Motor Company came to an end, the club was invited to become a founding member of the newly formed Football League Third Division North. Following a subsequent reorganisation of the Football League's structure, Southport FC dropped into the newly formed Fourth Division. However, the club remained in the Football League for more than half a century, with the club's most successful era coming during the late 1960s and early 1970s when it twice achieved promotion to the Third Division.

Southport's time in the Football League sadly came to an end following the 1977/78 season. When the club finished next-to-bottom for the third consecutive time, the club narrowly lost a vote to be re-elected to the League and was replaced by Wigan Athletic. Southport FC was the last club to lose its Football League status through the re-election process, with automatic promotion and relegation to and from the Fourth Division being introduced in 1986/87.

The club has enjoyed some memorable cup runs during its history, notably when, in February 1931, Southport became the first team from the Third Division North to reach the quarter finals of the FA Cup before being comprehensively defeated

9-1 by Everton at Goodison Park. In 1998, the club made it to the final of the FA Trophy, the leading non-league cup competition. Around 10,000 Southport fans travelled to the old Wembley Stadium for the final, where the club was narrowly defeated 1-0 by Cheltenham Town.

These days, Southport FC continues to compete at non-league level, but the club's many loyal supporters still harbour hopes that one day the club will regain its Football League status.

Special Occasions

In September 1874, the *Southport Visiter* published a special two-page supplement to mark the official opening of the Winter Gardens. This vast entertainment complex occupied an eight-acre site between Lord Street and the Promenade. 'The auspicious ceremony of formally opening to the inspection of the general public the magnificent structure which has been erected at such immense cost near the south end of the Promenade ... took place on Wednesday and passed off with great éclat', reported the newspaper, adding that the event would 'be long remembered in the history of Southport'.

Consisting of two large pavilions connected by a covered promenade, the new visitor attraction is estimated to have cost a then colossal £100,000 to build (equivalent to around £12 million today). One of the pavilions housed

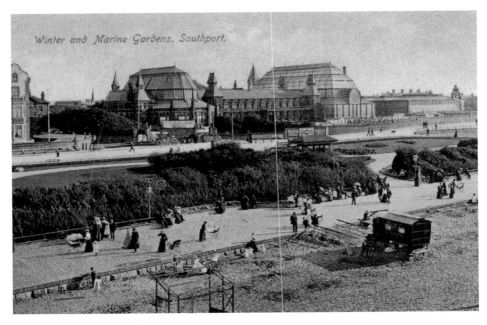

Winter Gardens postcard.

a 2,500-seater concert hall, while the other took the form of a vast glass conservatory, which at the time was the largest structure of its kind in the whole country, even surpassing the famed Palm House at Kew Gardens. An extensive aquarium was housed in the building's basement.

The *New Illustrated Guide* of 1884 aptly described Southport's Winter Gardens as 'a miniature Crystal Palace'. The original Crystal Palace had been specially constructed in London's Hyde Park to house the Great Exhibition of 1851. Designed by Joseph Paxton, this vast iron and glass structure had used construction techniques unlike anything which had ever been seen before. The finished building covered over 19 acres and is said to have required some 300,000 sheets of glass, which were supported by 1,000 cast-iron columns. Following the end of the Great Exhibition the Crystal Palace was dismantled and then subsequently rebuilt at Sydenham in South-East London.

The revolutionary techniques employed by Paxton to create the Crystal Palace were subsequently used by other Victorian engineers to construct similar vast glass pleasure-houses and thus the concept of creating indoor 'winter gardens', unaffected by the vagaries of the British weather, was born.

The Winter Gardens was undoubtedly the most impressive structure ever constructed in Southport, but almost from the start it failed to be a commercial success. Because of its sheer size, the vast glass conservatory was prohibitively expensive to maintain (the same issue also eventually led to the demise of the original Crystal Palace in London) and Southport, as a resort, simply could not support a venue that needed to attract a huge number of visitors just to survive.

The Southport Pavilion & Winter Gardens Company's financial resources were already stretched by the time the Opera House on Lord Street was opened as an additional attraction in 1891. This grand 2,000-seater venue was built on the site of a former roller-skating rink and was designed by the renowned theatre architect Frank Matcham. The Opera House attracted some high-profile stars of the day including the legendary actress Ellen Terry, who appeared there in November 1911. Sadly, however, this fine building was wrecked by fire in late 1929 and was too extensively damaged to be rebuilt.

Today, nothing remains of Southport's once famous Winter Gardens. Its iconic glass conservatory was dismantled in 1933. The pavilion was converted into a cinema and survived for a further three decades, but, in January 1962, was demolished to create a large car park. Subsequently a supermarket, which is now owned by Morrisons, was built on the site of the former Winter Gardens and, on entering the store, it is possible to view a mural which has been designed to commemorate the remarkable building that was once located there.

Late nineteenth-century American cowboy and frontiersman William F. Cody gained the nickname of 'Buffalo Bill' for reportedly killing over 4,000 buffalo single-handedly after winning a contract to supply meat to the Kansas Pacific Railroad so that the company could feed its construction workers. In the early 1880s, he came up with an entertainment spectacular unlike anything that had

been seen before, featuring wild animals, trick performances and large-scale theatrical re-enactments of battles and other historical events. After successfully touring the USA for four years, Cody decided to bring his Wild West Show to the UK in 1887 and more than 2.5 million tickets were sold for its first London run.

Cody subsequently embarked on several tours of the UK with his Wild West Show, but it was not until September 1904, on his very last UK tour, that he finally came to Southport. The chosen venue for this unique event was a piece of land on Ash Lane (later renamed Haig Avenue), close to the present home of Southport Football Club. Most of the performers arrived at Southport station in two specially laid-on trains and from there were transported to the venue in a convoy of waggons. However, by this stage Cody knew how to make an entrance and, on the morning of the show, he arranged for around 100 men on horseback, plus several stagecoaches, to parade through the centre of Southport. Their presence caused quite a stir and, no doubt, helped to generate further ticket sales for that day's afternoon and evening performances.

The performances included re-enactments of several famous Wild West events including daring raids on the Pony Express and the Deadwood Stagecoach, as well as the Battle of the Little Big Horn. Cowboys thrilled the spectators with daring bucking bronco displays and exhibitions showcasing their skilful shooting. A highlight of the show came when Buffalo Bill himself appeared on stage and proceeded to display his own impressive marksmanship. With his flamboyant theatrical attire of fringed leather jacket, white sombrero and long flowing hair, he appears to have created quite an impression on the large audience. 'Buffalo Bill looked a fine figure of the fellow', reported the *Southport Visiter*.

Late the following month, having completed their successful UK farewell tour, Cody and his performers set off from Liverpool on their journey home to New York. Southport would never see their like again.

In August 1924, Southport's first ever Flower Show was held over three days in Victoria Park. Now the largest independent Flower Show in the country, the event has been held annually at the same location ever since (except for the duration of the Second World War and a break of two years during the Covid-19 pandemic).

Southport's then mayor, Alderman Charles Aveling, came up with the idea of a Flower Show in 1924, as Southport's alternative to the British Empire Exhibition, which was held in London that year. In addition to exhibitors from all over the country, the main attractions at the first show in 1924 included 'horse leaping' events each afternoon, as well as performances from the bands of the Life and Grenadier Guards.

Victoria Park was first opened in 1884 and in its early days was separated from the adjoining Birkdale Park by a large hedge. When, in 1912, Birkdale was amalgamated with Southport, the hedge was removed and the two parks became one. Rotten Row, which runs parallel with the park down one side, was substantially remodelled at around the same time and the spectacular half-mile herbaceous border, for which it is now renowned, was created.

Above, below and opposite: Rotten Row.

Over the years, Southport Flower Show has grown and now features all kinds of trade stalls and special marquees for crafts and cookery demonstrations, in addition to the Grand Floral Marquee, show gardens and refreshment stalls for which it has been well known from its earliest days. Victoria Park's bandstand is also still put to good use by different musical groups throughout the four days of the show.

Victoria Park Bandstand.

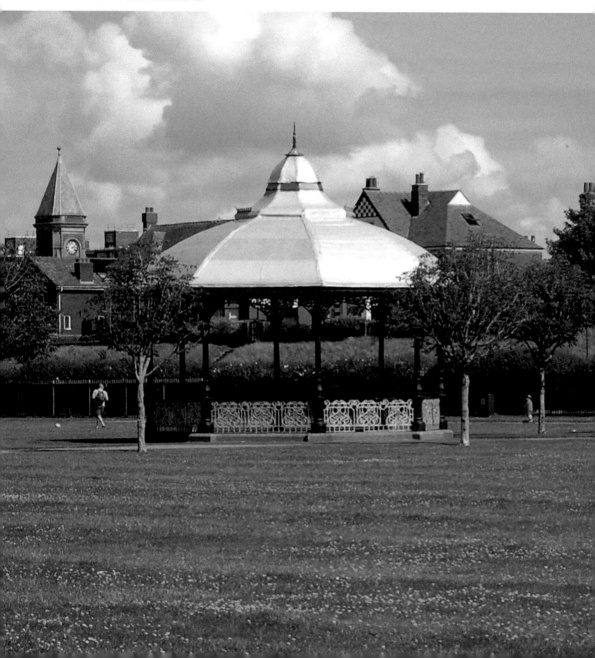

Interesting Headlines

The story of Phineas Taylor Barnum has been portrayed many times on stage and screen, most recently in the 2017 Hollywood blockbuster musical *The Greatest Showman*, in which he is portrayed by Hugh Jackman. However, Barnum's connection with Southport remains little known, possibly because this reveals a different side to the great American entrepreneur than the way in which he is usually portrayed in the fictional versions of his life.

Born in 1810, Barnum enjoyed his first big commercial success during the early 1840s after opening 'Barnum's American Museum' in New York. Barnum knew how to attract publicity, often by means of outrageous stunts, and his enterprise became a big hit. He subsequently turned his attention, with great success, to promoting musical acts, most notably Swedish soprano Jenny Lind. In later life, he launched 'The Greatest Show On Earth', the hugely ambitious travelling circus for which he is today best remembered.

As well as a menagerie of animals, Barnum's New York attraction became famous for its 'human curiosities'. One, Charles Sherwood Stratton, became famous as 'Tom Thumb, The Smallest Person That Ever Walked Alone'. Barnum took Stratton on his first tour of the States when the performer was just five years of age and, from then onwards, 'Tom Thumb' toured all over the world including, in 1858, a memorable appearance at Southport Town Hall. The *Southport Visiter* reported that Barnum travelled with his act to the resort and was said to have remarked that he 'had rarely seen so pleasing and beautiful a spot as Southport'.

According to Barnum's autobiography, the American entrepreneur was introduced to a Lancashire businessman called John Fish at around the same time, after giving a lecture at Manchester's Free Trade Hall. Fish had by this stage already built up a prosperous cotton manufacturing business and is said to have attributed his success to having followed the principles set out in a self-help book, written by Barnum, on how to make money in business. 'He informed me that he was joint proprietor with another gentleman in a cotton mill in Bury, near Manchester', wrote Barnum, adding that Fish then told him, 'Only a few years ago I was working as a journeyman, and probably should have been at this time, had it not been for your book'.

Thus began a long association, which Barnum held in such regard that he devoted a whole chapter of his autobiography to Fish. The account of his friendship with Fish includes such gems as the story of the occasion on which, with Barnum now back home in the States, Fish was sent to Paris on a mission to measure the height of a French 'giant', alleged to be some 8 feet tall, whom Barnum was interested in employing. Disappointingly, for the American showman, Fish found the Frenchman to be nowhere near as tall as advertised.

By the time of the 1871 census, John Fish and his family were enjoying the fruits of his business success and had moved to Southport, living in Portland Street, not far from the Prince of Wales Hotel. Barnum is known to have stayed at the family's home in the resort and may well have first encountered Fish's daughter, Nancy, there.

Barnum was married to his first wife, Charity, for over forty years, but she rarely travelled abroad with him. In November 1873, she passed away at home in the States, whilst the great showman was travelling in Europe, but he did not return home for her funeral.

Just under a year later, in early October 1874, Barnum's marriage to John Fish's daughter, Nancy, at the Church of the Divine Paternity in New York, was widely reported in the press. Described as 'a young lady of 26 summers, lithe and pretty', Nancy was wearing 'a slate-coloured dress ... and a black velvet hat with blue feathers'. Barnum, who was nearly forty years her senior, 'was attired in an evening dress suit'.

Research has, however, recently come to light that suggests Barnum and Nancy were, in fact, married in London on Valentine's Day 1874, only a matter of weeks after Charity's death. Barnum is said to have then returned to the States without his new wife, before Nancy joined him for the second 'official' wedding ceremony in New York some nine months later.

Following Barnum's death, at the age of eighty, in 1891, the former Miss Nancy Fish of Southport continued to enjoy a colourful life. She subsequently remarried twice, firstly to a Turkish diplomat and then to a French nobleman. When her businessman father, John, died in August 1901, he left the then substantial sum of £20,000 (equivalent to about £2.5 million today). In their later years, he and his wife, Martha, are known to have moved to a larger property on Victoria Street, which still exists today. Nancy herself died in Paris in June 1927.

On 16 December 1886, the *Southport Visiter* included a sombre report concerning the funerals of fourteen Southport lifeboatmen, who had lost their lives during a heroic attempt to rescue the crew of a German cargo vessel, called the *Mexico*. The newspaper reported that 'Lord Street and all the streets and route of the separate and combined processions were lined with sympathising spectators'.

Six nights earlier, the *Mexico,* having set sail from Liverpool bound for South America, had blown off course during a violent gale and ran aground off the north-west coast. Southport's lifeboat, the *Eliza Fernley,* was the first to be

launched. The *Southport Visiter* reported that the *Eliza Fernley* was approaching the *Mexico* and the men were about to launch a rescue attempt when the lifeboat was capsized. All but two of the sixteen crew members were tragically killed.

All thirteen crew members from a second lifeboat, the *Laura Janet* from St Annes, were also lost in the rescue attempt, before, eventually, crew members from a third lifeboat, the *Charles Biggs* of Lytham, were able to rescue the men on board the *Mexico*.

Even before this terrible incident, Southport's coastline had long been known as one of the most treacherous in the country. For years local fishermen had taken on the responsibility of assisting those ships that found themselves in difficulties off the coast of North Meols, before, in 1860, a Bolton businessman named James Knowles made a sizeable donation to the RNLI with a view to providing Southport with a new lifeboat. The first official lifeboat station in the resort was constructed the following year.

With twenty-seven men losing their lives in one night, the *Mexico* tragedy is still regarded as being the worst disaster in RNLI history. It made headline news across the whole country, and Queen Victoria and Kaiser Wilhelm were among those who contributed to a public appeal raising money for the families of the lost lifeboatmen. Within a matter of weeks, a new self-righting lifeboat, the *Mary Anna,* was put into service at Southport. It says much for the men of the town that there were said to have been many applicants to join the new crew.

Former Southport Lifeboat Station.

To the horror of many, the RNLI decided to close Southport's lifeboat station in 1925 and more than sixty years then elapsed before an independent lifeboat service, the Southport Offshore Rescue Trust, was established by local residents. Since then, the Southport lifeboat service is estimated to have assisted in the rescue of more than 400 people. The old boathouse was replaced, in early 2022, by a larger purpose-built lifeboat station, the construction of which has been funded entirely by public donations.

In June 1888, two years after the *Mexico* tragedy, a monument in the form of an obelisk was placed in the King's Gardens, close to the Promenade. This memorial still stands today as a tribute to all those brave Southport lifeboat crew members who have lost their lives at sea.

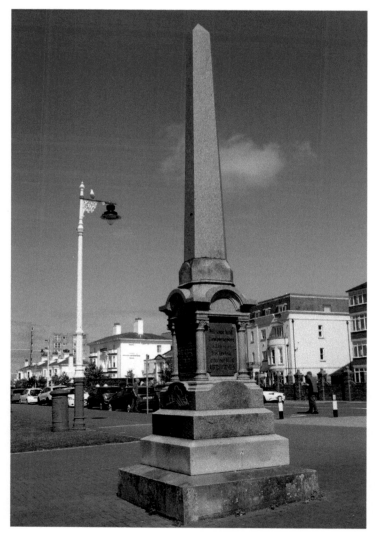

Lifeboat Memorial close to the Promenade.

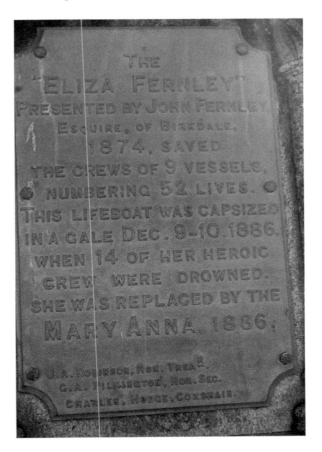

THE
"ELIZA FERNLEY"
PRESENTED BY JOHN FERNLEY
ESQUIRE, OF BIRKDALE,
1874, SAVED
THE CREWS OF 9 VESSELS,
NUMBERING 52 LIVES.
THIS LIFEBOAT WAS CAPSIZED
IN A GALE DEC. 9-10.1886,
WHEN 14 OF HER HEROIC
CREW WERE DROWNED.
SHE WAS REPLACED BY THE
MARY ANNA, 1886.

J.A. ROBINSON, HON. TREAR.
G.A. PILKINGTON, HON. SEC.
CHARLES. HODGE, COXSWAIN.

Eliza Fernley plaque on memorial.

Aviation pioneer Claude Grahame-White, who was one of the first Englishmen to qualify as a pilot, made headlines when, in August 1910, he unexpectedly landed his biplane on the sands close to Southport Pier. Grahame-White is reported to have set out from Blackpool towards Lytham, but, after seemingly going off course, eventually landed 8 miles away in Southport. According to one local newspaper, the intrepid pilot's landing on Southport beach caused such excitement that, 'Mounted police had to be employed to keep the crowds from approaching too near the aeroplane'.

During the following summer, Claude Grahame-White was booked, for the then hefty fee of £2,000, to appear at the resort's first ever air show, an event that formed part of Southport's four-day celebration to mark the coronation of King Edward VII.

In more recent times, the idea of holding an air show has been successfully revived. The annual Southport Air Show has proved a successful addition to the resort's events calendar since the first occasion on which it was held in September 1991. Now attracting tens of thousands of visitors every year, spectators have witnessed spectacular displays from historic Spitfire and Lancaster bombers to

today's mighty Typhoons and Chinooks, as well as regular appearances by the Red Arrows.

A metal sculpture of a vintage Lockheed Electra aeroplane above a New York skyline in the seemingly incongruous setting of the Shore Road roundabout near Ainsdale commemorates another pioneering aviator. Installed in 2010, it represents a fitting tribute to the part Ainsdale Beach played in an important part of aviation history.

On 2 September 1936, American pilot Dick Merrill took off from Floyd Bennett airfield in New York with the aim of making the first transatlantic round-trip by plane. He was accompanied by Broadway star Harry Richman, a millionaire whose specially modified Vultee V-1A monoplane, the *Lady Peace,* was being used for the attempt.

Richman himself was reportedly responsible for one of the more unusual modifications to the plane, suggesting that its wings be filled with some 41,000 table-tennis balls. It was hoped this would help the aircraft to remain afloat if the worst happened and it ended up in the ocean. As a result, the historic attempt has become known as the 'Ping-Pong Flight'. Ever the entrepreneur, the enterprising Richman is said to have autographed and sold the ping-pong balls for years after the mission.

The duo's journey across the Atlantic was eventful. Disrupted by bad weather, they were compelled to make an emergency landing in Wales, before continuing to their planned destination of London the following day.

Aeroplane sculpture on Shore Road roundabout near Ainsdale Beach.

Merrill and Richman were also compelled to change their plans for the return journey. The pair had originally intended to take off from Liverpool's Speke Airport, which at the time had the longest commercial runway in the country. However, because of the then exceptionally large amount of fuel that was required for a transatlantic flight, it soon became apparent that even this runway would be too short.

Fortunately, a solution was close to hand in the form of the wide stretch of unbroken sand between Ainsdale and Birkdale. Before their flight, the two intrepid aviators were guests of honour at a special American-style breakfast party hosted by the Prince of Wales Hotel on Lord Street. Merrill and Richman then proceeded to Birkdale Beach, from where they set off on their historic return journey across the Atlantic. 'The Birkdale shore was like a fairyland with the lines of lanterns set out as route guides for the craft', reported the *Formby Times*.

The town's name appeared in newspapers across the globe carrying reports of the historic flight. The *Formby Times* commented that, 'The golden sands of Southport have again proved a gilt-edged item in the town's publicity'.

Less than a year later, Dick Merrill was hired by US newspaper magnate William Randolph Hearst to repeat his epic transatlantic round-trip, along with a new co-pilot named Jack Lambie. Setting off in a Lockheed Model 10E Electra, appropriately nicknamed the *Daily Express,* the outward journey from New York to London was timed to coincide with the coronation of King George VI on

Prince of Wales Hotel.

10 May 1937. Hearst was hoping to pull off a significant publicity coup, aiming to be the first in the United States to publish photographs of the big event.

Southport's civic leaders were doubtlessly delighted when Merrill, once again, opted to use the town as his departure point for the return journey. On the evening of 13 May 1937, a large crowd gathered on Birkdale Beach to witness the *Daily Express* take-off on what became known as the 'Anglo-American Goodwill Coronation Flight'. The duo arrived home without incident and Hearst had his exclusive, with his US publications gaining access to photographs of the coronation before any of their rivals.

The event also proved to be another publicity triumph for Southport. Shortly after Merrill's second successful transatlantic round-trip in May 1937, the *Lancashire Evening Post* ran the following report:

> On the two occasions that airmen have set off from Southport for America, the town has received publicity for which it could not hope to pay in years ... Southport's sands have been responsible for a lot of world advertisement for the town. Apart from Atlantic take-offs, there have been three world record-breaking attempts, two by motorists and one by a motor cyclist, which received international publicity and cost next to nothing. Also, but for sandhills of former days, Southport would not be staging the Ryder Cup for the second time in June, on the Southport and Ainsdale course. They are golden sands, indeed.

Southport Miscellany

The list of stars, who appeared in Southport during the first part of the twentieth century, reads like a 'Who's Who' of the British music hall era.

The legendary Charlie Chaplin appeared at Southport early in his career before he found fame and fortune in Hollywood. From the age of eleven, he performed in a clog dancing group known as *The Eight Lancashire Lads* (although Chaplin himself originally hailed from London), who made appearances in variety shows across the country including all the main north-west seaside resorts.

Chaplin's big break as a comedian came when he was recruited by the influential theatre impresario, Fred Karno – an association which would eventually lead to his life-changing move to the USA. According to the painstaking research undertaken by A. J. Marriot for his book *Charlie Chaplin: Stage by Stage,* the iconic slapstick star appeared in a 1908 Karno production at Southport's Pier Pavilion Theatre.

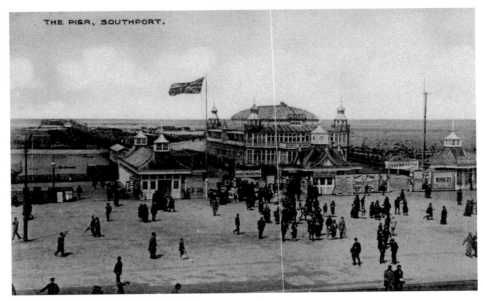

Vintage postcard featuring former Pavilion at the pier entrance.

Opening on New Year's Day 1902, the Pier Pavilion Theatre was situated in a prime spot at the Promenade end of the pier, which is today occupied by the Funland amusement arcade. The theatre replaced an earlier pavilion, which had been destroyed by fire four years previously, but was much more ornate and ambitious in design than its predecessor.

Another famous name to appear at the Pier Pavilion in those pre-First World War days was George Formby, but not the 1930s ukulele-playing stage and screen star of *Leaning On A Lamp Post* and *The Window Cleaner* fame. His father, from whom the entertainer inherited his stage name, is less known today. Yet George Formby Sr was an extremely popular music hall star in the early years of the twentieth century, as is illustrated in this extract from a review of his performance at Southport's Pier Pavilion in April 1911:

George Formby is a born comedian, that is where his charm comes in. He never has to force a joke, and when on the stage repeatedly tells the audience what he is thinking of – and it is always something funny … The audience simply has to laugh itself hoarse – there is nothing else for it – for every moment some ludicrous and quaint remark or expression rolls from his tongue.

Carousel near modern entrance to pier.

Close-up of carousel.

Bud Flanagan and Chesney Allen, a famous British comedy double act whose heyday came in the interwar period, also proved popular with audiences at the Pier Pavilion. One performance at the venue in 1927 proved to be a particularly significant moment in the duo's career. During a later interview for a 1957 TV programme, Flanagan himself recalled that he wrote the act's most famous song, 'Underneath the Arches', whilst staying in Derby in 1927, and the pair then performed it on stage for the first time the following week at the Pier Pavilion.

Only a few years after this landmark performance, the Pier Pavilion was extensively refurbished and its name changed to the Casino Theatre. The venue continued to stage plays and light entertainment shows until 1969 when it was finally demolished.

During the early years of the twentieth century, Southport Pier was also famous for its divers who entertained the crowds by diving into the sea from the roof of the tea house at the end of the pier. Pier diving was a popular attraction at seaside resorts throughout the country and the best-known practitioners were accustomed to using the honorary title of 'Professor'.

A one-legged diver named 'Professor' Frank Gadsby was famous for his appearances at Southport Pier. Having suffered the misfortune of having had a leg amputated at a young age, the remarkable Gadsby later embarked on a successful career as a daredevil diver. Another diver, 'Professor' Bert Powsey, was renowned for jumping off the pier on a bicycle. They are both depicted in a series of striking

Left: Modern sculpture commemorating Southport's pier divers.

Below: Close-up of divers' sculpture.

Right: Metal sculpture of one-legged pier diver.

Below: Metal sculpture of pier diver on bicycle.

Above left: Metal sculpture of the sun.

Above right: Metal sculpture of shrimp.

metal statues, which were added to the Promenade during the late 1990s to commemorate the history of Southport's seafront.

Another once famous Southport entertainment venue was located on the Lord Street site, which is now occupied by a Sainsbury's supermarket. The Palladium opened in early 1914. The building boasted a fine Italian Renaissance-style façade, which remained largely unscathed despite the interior suffering severe fire damage on several occasions. It was still a notable feature when the cinema was controversially demolished during the summer of 1980.

Mermaid fountain close to former location of the Palladium.

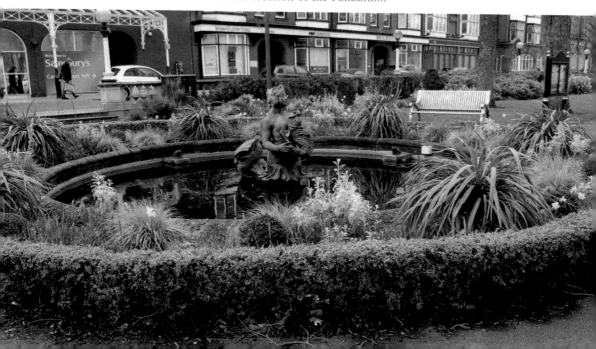

Close-up of mermaid
fountain.

Initially, the Palladium operated primarily as a theatre, but on Sunday, the performers' day-off, showed films. In the early 1930s, the decision was taken to focus on the cinema side of the business and the resident orchestra was disbanded on grounds of cost, but this was not the end of live entertainment at the venue by a long stretch. Following the arrival of Ken Lloyd as manager in the late 1950s, the Gaumont, as it was by then known, began to stage live shows again and some of the biggest stars of the 1950s and 1960s made special 'one-night only' appearances there.

Most famously, The Beatles performed at the venue on several occasions during 1963. The group had already appeared in the town at three other locations, the Kingsway Club, the Floral Hall and Club Django at the Queen's Hotel, before appearing for the first time at the Lord Street venue, now renamed the Odeon, in March 1963. It is difficult to imagine now, but for this first appearance the 'Fab Four' were fourth on an eleven-act bill, headed by the then sixteen-year-old singer Helen Shapiro. Such was the group's meteoric rise to fame, however, that by the time The Beatles returned to the Odeon later the same year, 'Beatlemania' was already well and truly underway.

Prior to the group's six-day residency at the Odeon in late August 1963, the *Liverpool Echo* reported that, 'Extra police will be on duty round Southport's Odeon Cinema next week for the six-day visit of Britain's No. 1 beat group, The Beatles. A number of different routes in and out of the theatre have been arranged to protect the Merseyside group from being mobbed by fans'. The 'Fab Four' performed two shows each night for six consecutive days, with the set containing such early Beatles classics as *She Loves You, From Me To You* and *I Saw Her Standing There*.

During the early 1930s, Italian artist Fortunino Matania was specially commissioned by Southport Corporation to produce a series of iconic posters which were intended to advertise the resort as an all-year round tourist destination. The Naples-born artist regularly exhibited at the Royal Academy and had several high-profile patrons including Queen Mary.

One of Matania's posters portrays Lord Street on a winter's day, accompanied by the tagline 'Southport – A Charming Winter Resort'. Another features the Garrick Theatre, also on Lord Street. Situated on the site previously occupied by Southport's grand Opera House, the Garrick Theatre was described at its opening in December 1932 as 'one of the finest places of entertainment in the country'. The building's days as a theatre ended in the late 1950s and it was subsequently used as a bingo hall for many years. However, many of its fine art deco details survive to this day, and, with the site now under new ownership, it would be great to think that one day it may be used again as a theatrical venue.

In Matania's poster, glamorous theatregoers in full evening dress are pictured exiting the Garrick onto a lamplit Lord Street. Once one of the resort's best-

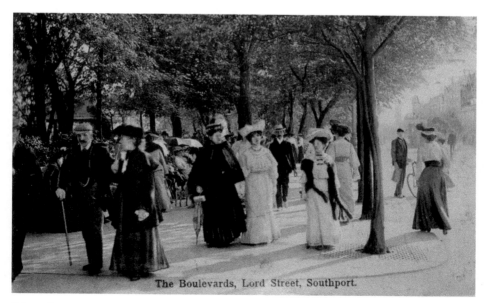

The Boulevards, Lord Street, Southport.

Edwardian era postcard showing the fashions of the day on Lord Street.

Above: Former Garrick Theatre.

Right: David Garrick plaque on wall close to former theatre.

loved features, the tradition of Southport's main thoroughfare being illuminated at night has recently been revived. Starting in early 2021, a grand total of 300,000 new decorative light bulbs have been installed on Lord Street's trees, creating a magical lighting effect that would have not looked out of place on one of the Italian artist's posters.

Lord Street's modern illuminations.

All of Matania's bold, colourful paintings depict the Southport of the interwar years as an elegant resort, which is frequented by a rich and glamorous clientele that would be more readily associated with the French Riviera. Never is this more evident than in Matania's poster to showcase the 'Venetian Nights Spectacular' events, which were staged in the resort during the summer months from 1932 until the outbreak of war in 1939.

The Marine Lake, including the then recently opened Venetian Bridge, was illuminated with coloured fairy lights. Whole families dressed up in costumes inspired by those seen at the famous Venice Carnival. Gondolas, lit by lanterns, sailed on the Marine Lake, with some passengers playing or singing along to musical instruments. As with all open-air entertainments in this country, the weather could occasionally play havoc, but it is impossible to view Matania's beautiful depiction of an idyllic 'Venetian' evening on the Marine Lake and not look back with wistful nostalgia to a seemingly more glamorous and elegant era.

The Lakeside Miniature Railway, on the seaward side of the Marine Lake, has been a popular attraction with visitors ever since it first opened in May 1911 and now boasts of being the oldest continuously running 15-inch gauge railway in the world. It was originally conceived to connect Southport's growing amusement

Above: Miniature railway locomotive.

Below: People enjoying a ride on miniature railway.

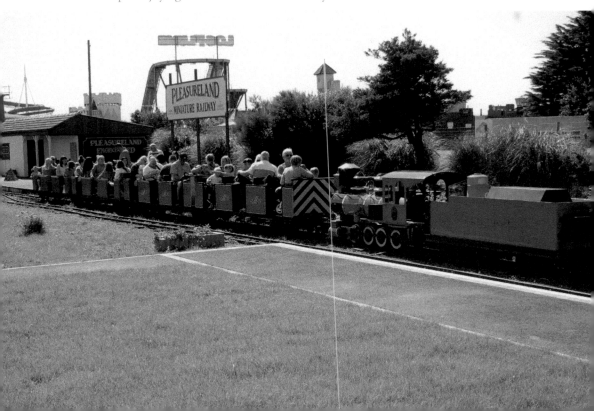

park, then known as the White City, with the pier and was operated in its early years by Griffith Vaughan Llewelyn, as a result of which the railway soon became known as Llewelyn's Miniature Railway. The carriages were originally drawn by miniature steam locomotives. However, by the 1950s, these had been replaced by petrol-driven engines, although they were at least made to look like the old steam locomotives (as they still do today).

During the mid-twentieth century, Birkdale-based engineer Harry Barlow took over the line and it became known by its present-day name of Lakeside Miniature Railway. Barlow became famous nationally for his expertise in building and restoring miniature railways and, in 1951, the Birkdale man was asked to undertake a special project for that year's Festival of Britain. An eccentric cartoonist named Rowland Emmett had sketched designs for a hypothetical line, which he dubbed the 'world's craziest railway'. Barlow was asked to bring this to life and the *Far Tottering and Oyster Creek Railway*, as it became known, proved to be one of the biggest hits at the Festival of Britain.

Current owner Norman Wallis, who is also the man now in charge at nearby Pleasureland, purchased the railway in 2016. He has already overseen work to improve the line's track and surroundings, adding attractions such as a café, carousel and helter-skelter, and is said to have plans to create a heritage museum.

Another exciting new attraction, close to Pleasureland, opened in early 2022, in the form of a 35-metre-tall observation wheel. Not only does this ride offer an

Carousel by miniature railway.

Southport's big wheel.

unparalleled bird's-eye view of Southport, but also, on a clear day, it is possible to enjoy views of the spectacular countryside beyond the resort stretching as far as North Wales and the Lake District.

In my introduction to this book, I referred to Southport's ability, in the past, to meet challenges and adapt to changing circumstances. During my research, it has become increasingly apparent to me that in response to the recent Covid-19 pandemic, this is also exactly what the resort is doing now. I have referred in this book to several exciting new initiatives, which are already up and running. Driven by local civic and business leaders, there appear to be plenty more exciting developments still in the pipeline. In celebrating what this fine town has achieved in the past and what it has to offer now, it is also satisfying to be able to look forward, with renewed optimism, to what it can achieve in the future.

About the Author

Margaret Brecknell is a freelance writer from north-west England with a passion for history, particularly relating to the places that she, or close family members, have called home. After graduating from Manchester University with an honours degree in Latin, she worked in stockbroking for many years. She is now able to focus on her writing and her work has appeared in a wide range of different publications, both at home and abroad.

Margaret can be found on Twitter: @mabrecknell.

Acknowledgements

All the photographs in this book were taken by Christopher Windle, to whom I am extremely grateful. Postcards are from my own personal collection.

The photographs of the Red Rum and Toad Hall murals are included by kind permission of the artist, Paul Curtis. For details of his other artwork, please visit www.paulcurtisartwork.com.